SEA LIGHT

For my parents–Anna and Paul Liebhardt

Published by

Institute for Shipboard Education

811 William Pitt Union

University of Pittsburgh

Pittsburgh, Pennsylvania 15260

SEA LIGHT
Searching for Humanity

Library of Congress Catalog Card Number: 97-075323
ISBN 0-9659227-0-7

Design, Digital Production and Printing by Media 27, Inc., Santa Barbara, California
Printed in Hong Kong

SEA LIGHT

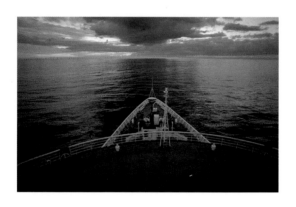

SEMESTER AT SEA ≈ A PHOTOGRAPHIC ESSAY BY
PAUL LIEBHARDT

FOREWORD

—

Archbishop Desmond Tutu

Anyone who did not live in South Africa under apartheid can't begin to understand what it was really like. Inter-racial hatred, oppression, and divisiveness had reached a terrible and terrifying apogee. And what was it really about? What it is always about of course: fear, power, and money. Perhaps there is little we can do to eliminate the apparently natural human appetite for power and money, but there is a great deal we can do about eliminating fear — the fear that grows from lack of understanding.

As I told the members of the Cape Town Press Club in June 1995, traveling enables us to observe trends and developments in countries around the world at first hand. Today, much of our world is going through a period of transition. Such times inevitably generate great anxiety and uncertainty because that which has been familiar to us has suddenly shifted course or disappeared altogether. We are left feeling disoriented, without direction, even without purpose. We rejoiced at the collapse of the Berlin Wall and the Communist Empire because it signaled the end of the Cold War, and we very much hoped it would lead to a worldwide rebirth of freedom and democracy. In many ways, that dream is in the process of coming true, but there is also a down side.

We had grown accustomed to using the Berlin Wall and the Iron Curtain as reference points to help us find our ideological bearings and to make sense of what could be a bewildering geopolitical landscape. We knew who were our enemies and who were our friends. Perhaps even more important, they provided us with convenient scapegoats to blame for things whenever our own political agendas made it necessary or desirable. It was easy to know what we were against. As it turned out, however, it was far harder to

know what we were for. In my country we might well have asked, however facetiously, "What are we going to do without apartheid?" It was so easy to say that we favored a non-sexist, democratic, non-racial society, but what then? There are so many philosophical options out there jostling for support that confusion and disillusionment soon descended upon us. Who is now the enemy? Why are things not more straightforward and simple? We found it difficult to put aside the tactics of struggle for strategies better suited to the altered political landscape.

Paradoxically, all this anxiety and uncertainty leads to nostalgia for the old dogmatic, unambiguous, and somehow comforting answers to complex questions we had before. With all their defects, we found in them not just our sense of purpose but, ironically, our sense of security as well. A new order is unfamiliar, untested, fraught with peril and the possibility of making mistakes. Anguished by our rediscovery of this complexity, fear of what is different — racially, culturally, ethnically — seizes us and we begin to crave a settled order to insulate us from that fear. The horrifying results emerge in places like Bosnia, with its "ethnic cleansing," and Rwanda where rival tribes have brutally massacred each other in a new wave of hideous genocide. Unfortunately, life furnishes few, if any, simple answers to complex questions.

But that hardly means our lot is a hopeless one. Not long ago, I had the good fortune to be a small part of a wonderful experiment in education called *Semester at Sea*. The mission of this grand experiment has been to foster greater intercultural understanding by exposing its participants — young and old, students and faculty — to people and cultures around the world while providing them with a sea-going classroom in which to study and absorb what they've seen and learned. In the great ocean of human affairs, this idea may seem like a small fish, but one fish can reach others and those others can reach still more until the great web of understanding and enlightenment spreads out to encircle the globe. Only in that way can we move beyond our fears and learn, finally, to live in harmony with ourselves and our planet. This book — inspired by one man's vision of that quest — may be a window on our future.

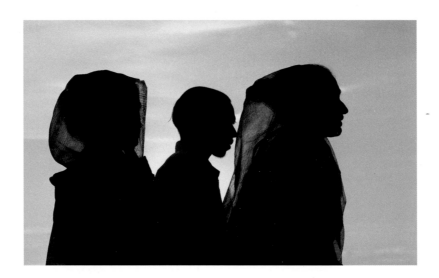

From a point in space, above the equator and centered on the first meridian east of the International Date Line, the sphere of Earth appears to be an almost unbroken blue, so vast is the expanse of the Pacific Ocean.

Except for New Zealand, land masses are visible only at the edges, and that is but one face of the water planet. So far as we yet know, the presence of all this water makes Earth unique. Not only is it the source and foundation of life on this planet, but since the beginning of recorded history it has also been the great connecting link in the destiny of man. In vessels of every conceivable shape and size, from ancient Egyptian feluccas to modern cruise ships and nuclear submarines, we have relied on it for trade, communication, travel, the spread of culture and, alas, the waging of war. Even today, in a time when technology continuously transforms our world at an ever-accelerating pace, when electronic communications have become virtually instantaneous, and when jet planes bring even the remotest destinations within reach in hours, we still go down to the sea in

ships. In a very real sense, water is our destiny. It is the element that binds us together in what we have come to think of as the global village.

True, you can get up tomorrow, pack a bag, hop a jet, and in hardly any time at all be half way around the world. Chances are, you'll arrive at an uncivilized hour feeling grubby and disoriented, your brain and body soggy with jet lag. You'll have to thread your way through an unfamiliar airport in a country where the language, culture, and currency are all unknown to you. If you've been lucky, your luggage arrived on the same plane you did. Now, all you have to worry about is retrieving it, getting through customs, and exchanging some money so you can head for your hotel. If your luck holds, the cab driver will take you there by the shortest rather than the longest route and you won't overpay him by more than a hundred percent because you haven't the faintest idea what the value of those funny looking bills really is, much less anything about local tipping customs. In a couple of days you'll catch up with local time, your circadian rhythm will return to normal, and you'll be able to immerse yourself intelligently in whatever it was you came for—except, of course, you aren't likely to have a couple of days to spend

readjusting your internal clock. Only a masochist would maintain that this way of getting there is half the fun. And yet, if time is money, or even if it's just "of the essence," this form of torture may well be inescapable for most modern travelers. But what if, just for once, time wasn't of the essence. What if your real goal was not a sales conference in Singapore, a business trip to Bonn, or a two-week vacation on some glittering Caribbean beach, but a quest for a better understanding of the global village? Then you might feel as John Masefield did when he wrote:

I must go down to the seas again,
for the call of the running tide
Is a wild call and a clear call that
may not be denied…

Romantic poetry from another time? Of course. Nevertheless, a few months spent sailing from port to fascinating port will yield a far greater understanding and appreciation of the world we live in than zipping around it on a jet plane. Because understanding takes time—time to think about where you're going, time to spend there, and time to reflect on where you've been and what you've seen.

If we've learned one thing from human history, it's that lack of understanding breeds intolerance

and intolerance often leads to violence and war. Now that we have achieved mass destruction capabilities, our very survival may depend on understanding. But true understanding does not come from the kind of travel that produced the "If it's Tuesday, this must be Thailand" jokes, or from dashing across the Atlantic on the Concorde to "do lunch" in London. It takes patience, determination, effort, and a lot of good will. A daunting challenge to be sure, and each individual step along the way may seem small and insignificant, but in fact the great currents of history move in just such small and seem-ingly insignificant increments. As Mao Tse-tung once observed, a journey of a thousand miles begins with a single step.

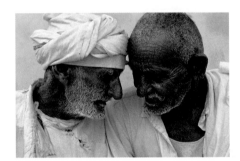

In the middle years of this tumultuous century, a photojournalist named W. Eugene Smith set himself the incredibly ambitious goal of attempting through his pictures to "document the entire human condition." In pursuit of that goal, Smith produced some of the most memo-rable photographs of our time, including an agonizing essay on the victims of mercury poisoning in the small Japanese village of Minimata. No one who saw those searing black and white images would ever be able to forget them for they seemed to have burst upon us straight from the innermost circle of Hell. For such a mission, photography comes close to being the ideal medium because of its unique ability to literally freeze moments in time. Sadly, an untimely death put an abrupt end to Smith's quest. It is by no means certain that, even had he lived a very long life, he would have been able to travel even a fraction of the distance toward his goal. But that is not important. What matters is that he tried, in his own unique way, to add to our knowledge and enlarge our understanding of ourselves.

That is, of course, the very essence of all art and education. But understanding is a journey, not a destination. We can never hope to reach the goal of total understanding because everything— even reality itself—is in such a constant state of flux. In this century alone the pace of change, with its concomitant expansion of knowledge, has accelerated steadily to the point where it now seems to be moving at warp speed. In

Aristotle's time, it was possible for him alone to know just about everything there was to know. Today, the sheer volume of knowledge is so immense that ten thousand of our greatest minds could encompass no more than a fraction of it, and it grows exponentially. What is "state of the art" in the morning may be rendered obsolete by afternoon. It's as if we were watching history unfold on fast forward. The images fly by at such dizzying speed that they seem almost subliminal and we are powerless to arrest them. The most we can hope for is a perpetual struggle just to stay in the race.

In many ways, this techno-logical progress seems little short of miraculous. A television ad shows us a group of people who have become lost in a rain forest. Their situation seems desperate and a few years ago it would have been, but not today. A young girl in the party sits down calmly, breaks out her laptop computer, logs on to the Internet, pulls up some geographical web site, pinpoints their location, and easily charts a course out of their predicament. This may seem implausible, a computer manufacturer's sales hype—but in fact it's the way much of the world works these days. The parts that don't yet work this way are the source of some of our most vexing and intractable problems as we approach the end of the millennium. While some of us race along at giddy technological speed, others, less fortunate, tend to become lost in the backwash. This breeds resentment, hostility, aggression—all the familiar and dangerous elements of human nature we know so well.

To what extent is a lack of understanding responsible for such horrors as "ethnic cleansing" in Bosnia, the ancient and seemingly interminable conflict between Moslem and Jew in the Holy Land, or the tribal massacres in Rwanda? Such grisly events are hardly unique to our time. They have been going on, for one reason or another, ever since we started keeping records. In the final analysis, there's very little difference between, say, the Assyrian or Hittite method of waging war and dealing with enemies three thousand years ago and what has been happening in Rwanda in our own time. Are we capable of rising, broadly and permanently, above our predilection for hatred

and prejudice? Can we learn to identify ourselves not as rivalrous members of some particular group, but as members of the greater family of man? Can we bring ourselves to put aside our bloodier instincts and recognize not only that we share a common destiny that transcends our differences, but that we have a far greater chance to achieve our shared goals if we row together instead of every oarsman seeking to steer the ship on his own preferred course? Unfortunately, our progress toward that end has been sporadic at best. As obvious as it may seem on its face, history has produced an endless parade of those who do not even see it as a desirable goal. On top of that, we have often discovered, as South Africa's Archbishop Desmond Tutu notes in his foreword, that it is far easier to know what we are *against* than to know what we are *for*. Never-the-less, as events in the Archbishop's own country so clearly demonstrate, progress *is* possible.

There is no simple, universal formula to guide us on the journey. If all it took was the accumulated weight of public opinion or the threat of external force, progress on human rights might have moved a good deal faster than it has. Intervention in Bosnia might not have been necessary. Rwanda's Hutus and Tutsis might not have been chopping each other up with such ferocity. Even when progress of a more or less dramatic nature does occur—as it did when the former Communist empire dissolved, or when South Africa abandoned apartheid without the bloodbath of a civil war—the road ahead does not suddenly and automatically become smooth or easy to follow. The exhilaration of victory often gives way to the agony of disillusion. New tyrants are always waiting in the wings. Fresh hostilities may erupt. It is not our laws, our beliefs, or our governmental systems that we have to overcome but our very nature. Progress on that front has been lamentably slow, uncertain, and subject to frequent regression.

If we are ever to succeed in overcoming our flawed nature it will only be as a result of an unflagging dedication to learning as much as we can about ourselves, our cultures, our history, and our common aspirations. It won't be easy and it won't happen soon, but it *can* happen and

travel—preferably with an open and curious mind—is an indispensable key to ensuring that it does. You might spend a few hours in your local library or with your daily newspaper reading about what's going on in the world, but that activity, while helpful and informative, lacks any sense of immediacy or personal involvement. There's a vast difference between reading about or looking at pictures of the Taj Mahal and the impact of actually seeing it first hand. The opulent Taj and the squalor found elsewhere in India are starkly contrasting parts of the same tapestry. Without witnessing both you cannot really understand either. It is easy, from the comfort of our living rooms, to pass judgment on events in far-away places. It is quite another thing to actually set foot there, to spend time with the people, to experience the quotidian content of their lives, their cultural traditions, their hopes for the future. Such experiences are life-altering. Enough of them can alter the course of history as well.

Paul Liebhardt, a photographer whose eye is attuned to the kaleidoscopic elements of the human drama, has been roaming the globe for many years, searching for his own connection to the "family of man." Looking at his pictures, it is impossible not to hear an echo of the thought once expressed by John Donne when he said, "No man is an island," for in these pictures the proof that we are none of us alone is there for all to see.

Once, while prowling around the village of Bobo Dioulasso in the West African country of Burkina Faso, Paul came upon a line of children, waiting outside the local theater to see an American film called *Richie Rich* in which child star Macaulay Culkin plays a wealthy adolescent. The scene may not have been the stuff of unforgettable photographs, but for Paul it became something of an epiphany. What message would these children, with so little chance ever to escape the grinding poverty of their homeland, take away from such a film? The story, after all, represented a way of life so utterly beyond their reach that it might just as well be taking place on another planet. Beyond their reach perhaps, but not beyond their comprehension, and more

significantly, not beyond their capacity for hope. It occurred to Paul that this inextinguishable capacity for hope—for being able to believe in the seemingly impossible even in so improbable a place as Bobo Dioulasso—is crucial to mankind's immense strength and relentless will, not just to endure, but to prevail. This irrepressible longing for a better tomorrow has driven us throughout history. We have stumbled badly and often along the way, but we have never surrendered to ultimate despair even in our darkest hours.

The twentieth century has witnessed the forging of an unprecedented chain of events. In the past hundred years, we have soared to breathtaking heights of progress and nobility and descended to horrifying depths of depravity. Technological advances made possible improvements in the quality of life our forebearers would have found inconceivable, but along the way we also engaged in endless cruelty and war—twice on a scale that threatened the very survival of civilization. Can it be possible that we have arrived at the age of instant worldwide communication only to perpetuate or even extend our prejudices, suspicions, and hatreds?

It is often easy to draw that conclusion, but ours is an infinitely complex, elastic, and adaptable species, capable of great inconsistencies and contradictions. In the wake of natural disasters we reach out to each other around the world with compassion and helping hands. But then, in the very next moment, we turn on each other with murderous savagery when some political or religious issue is involved. How can we reconcile these warring aspects of our nature? Will we, despite the often depressing evidence of history, eventually be able to put the brutal instincts that have so often characterized the affairs of men behind us once and for all?

Shipboard education grew out of the desire to pursue that very goal. There are, to be sure, many valid roads to this objective, but none that offer quite the same unique, mind-expanding opportunities of the "floating university." No one who takes one of these voyages can return without having learned to appreciate the importance of travel and the enriching exposure to other cultures it makes possible. With such

exposure (and equally vital to the development of global understanding) comes an enhanced grasp of the enormous complexity of the world's problems. Complex problems often mean complex solutions, if any, and we must accept the fact that our search for them can never have an end.

Whether or not such a goal is attainable, though, we dare not abandon hope that it is. To do that would be to deny the very quintessence of humanity with its unquenchable thirst for knowledge and a better life. The road to the top of this mountain has never been an easy one. Nor, perhaps, was it meant to be. Our struggle to ascend it defines us, makes us what and who we are, gives us our purpose. We cannot be certain what lies ahead. We cannot clearly see the summit, or even if it has one, but we accept that the road has only one direction and that, however often we may stumble and fall, we must always resume the upward journey. As Donne observed, we are involved in mankind.

In these pages, you will find its face. Smile. Say hello. Extend your hand. You won't be sorry.

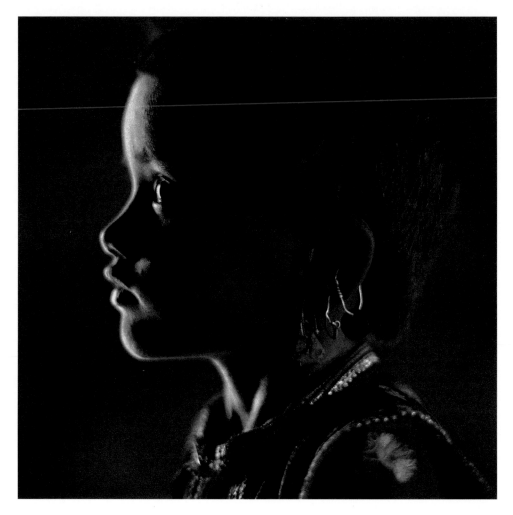

Jaisalmer, India

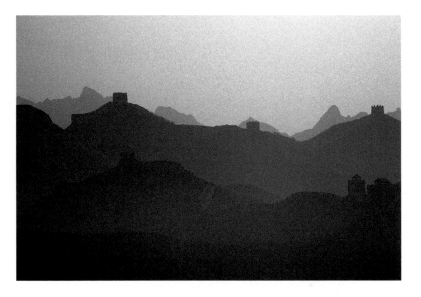

Jinshanling, China

Niger River, Ségou, Mali

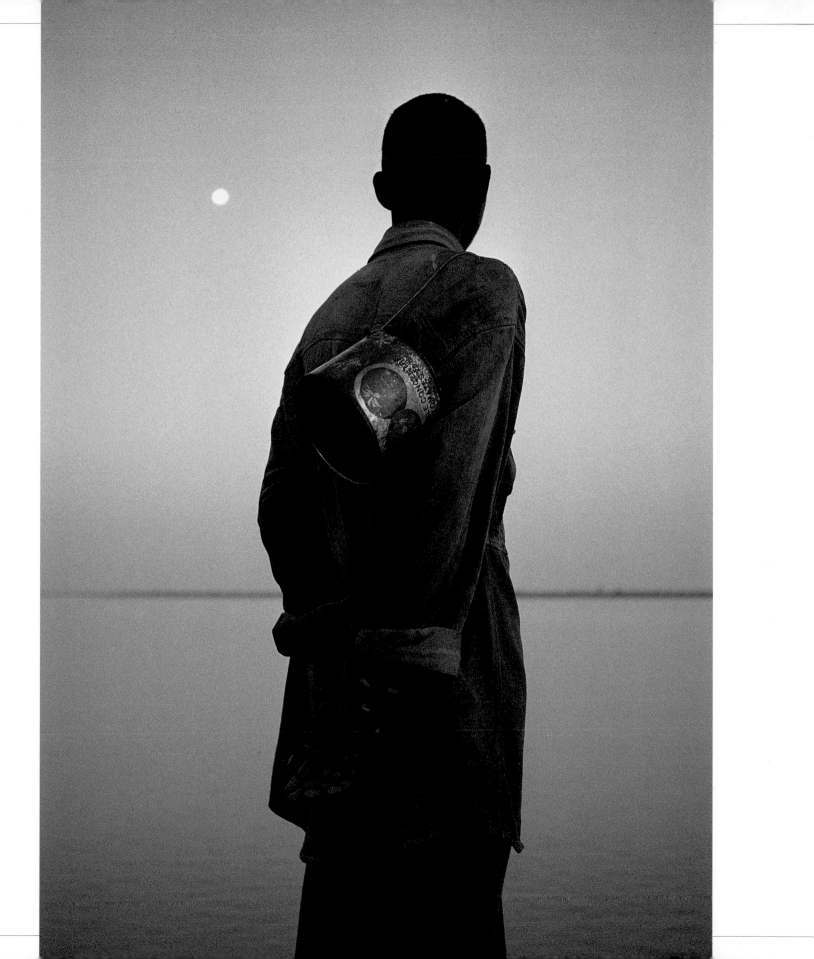

Lo such faces.

Walt Whitman

Amritsar, India

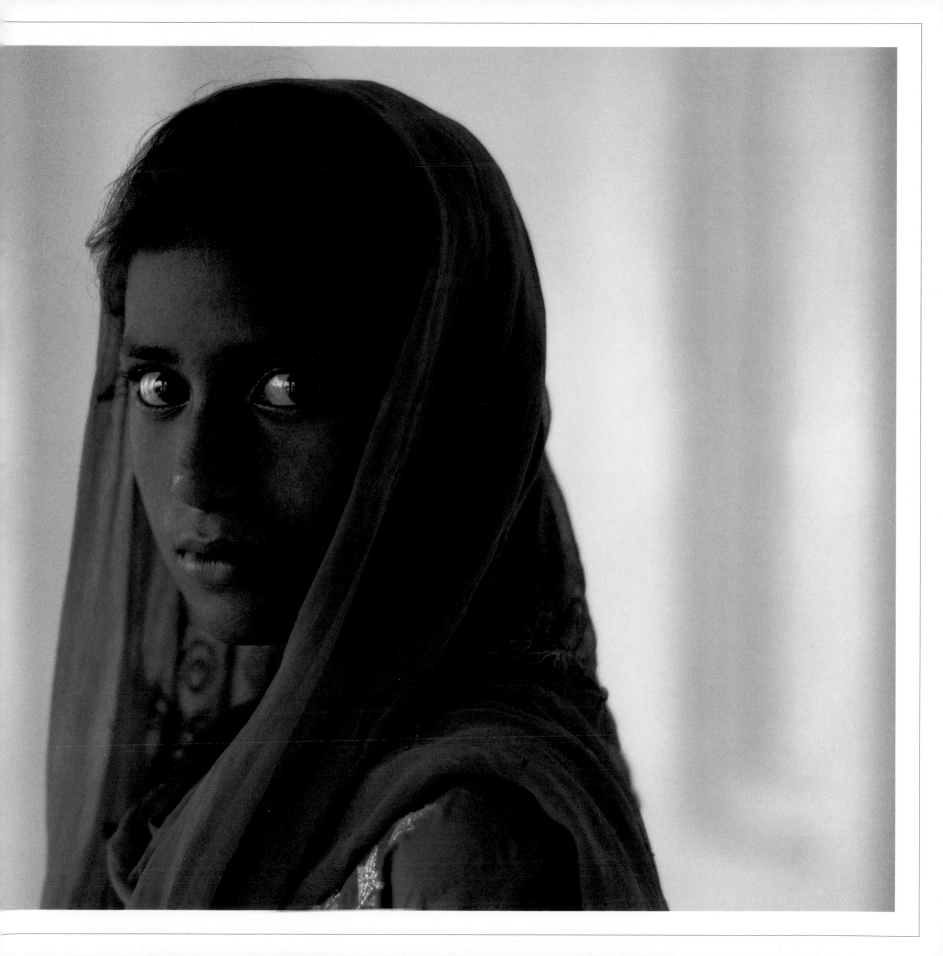

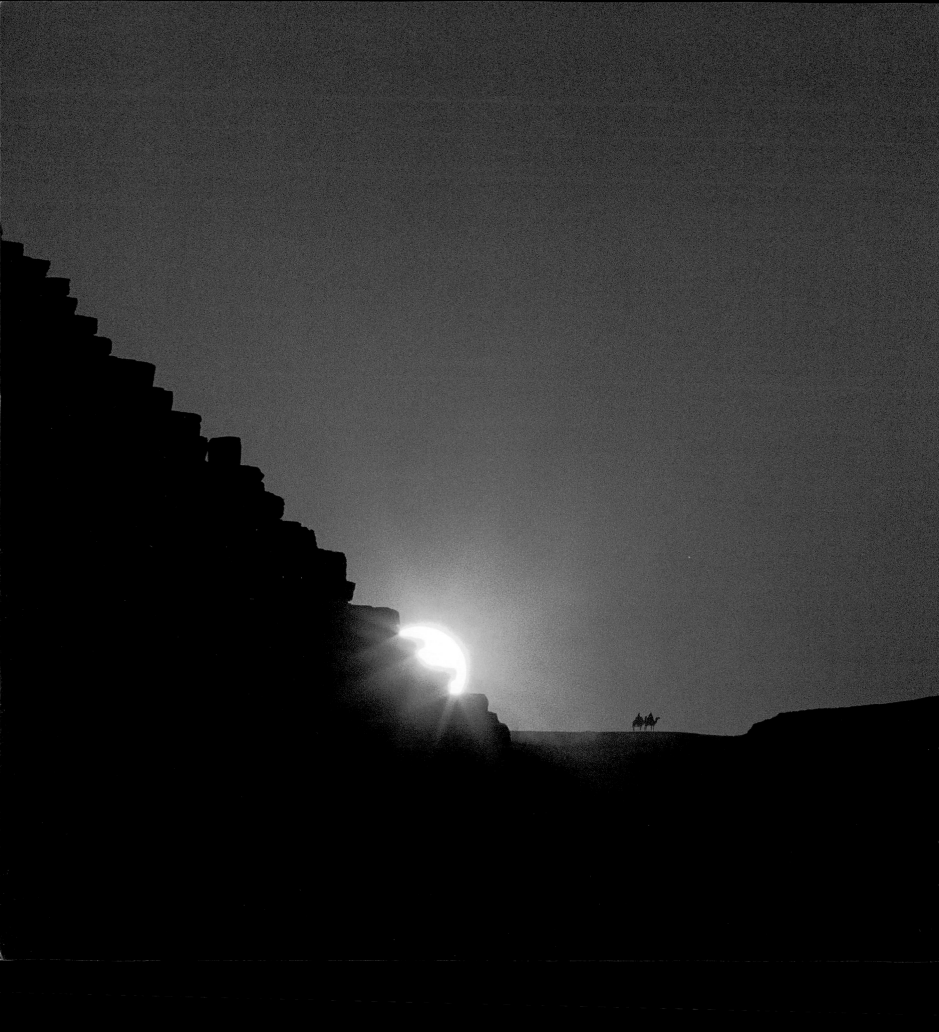

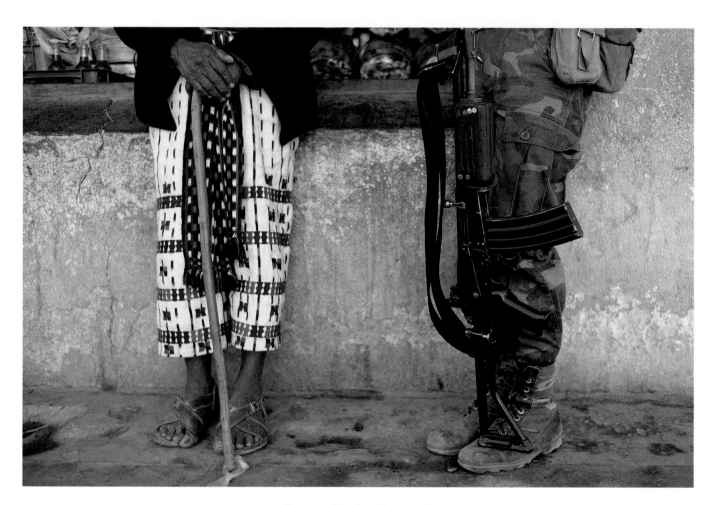

Santiago Atitlán, Guatemala

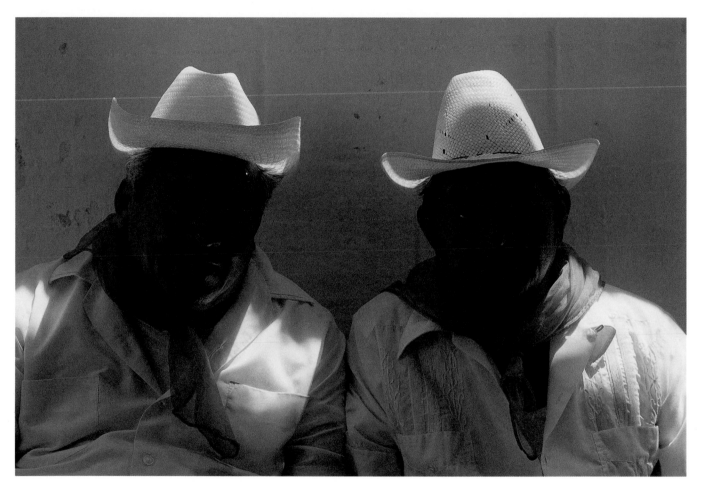

Tehuantepec, Mexico

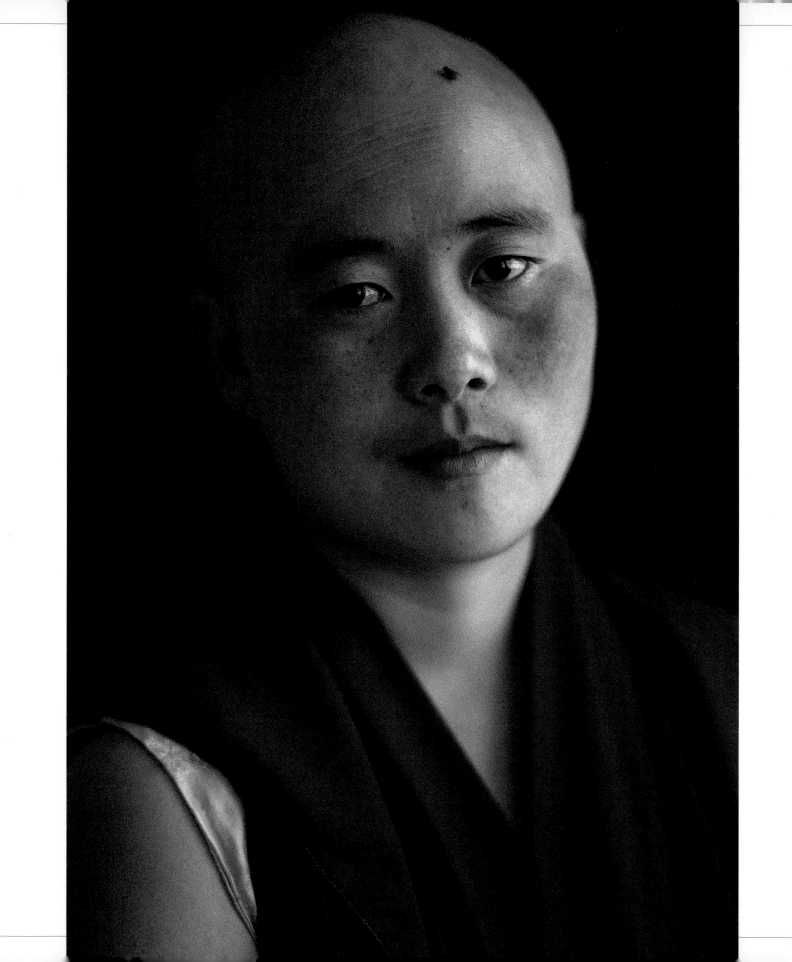

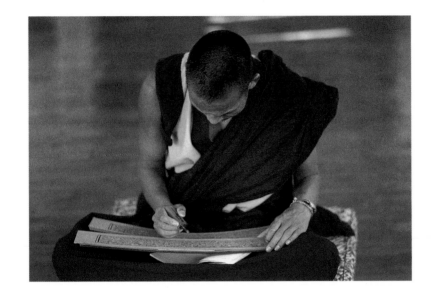

Dharamsala, India

Menghun, China

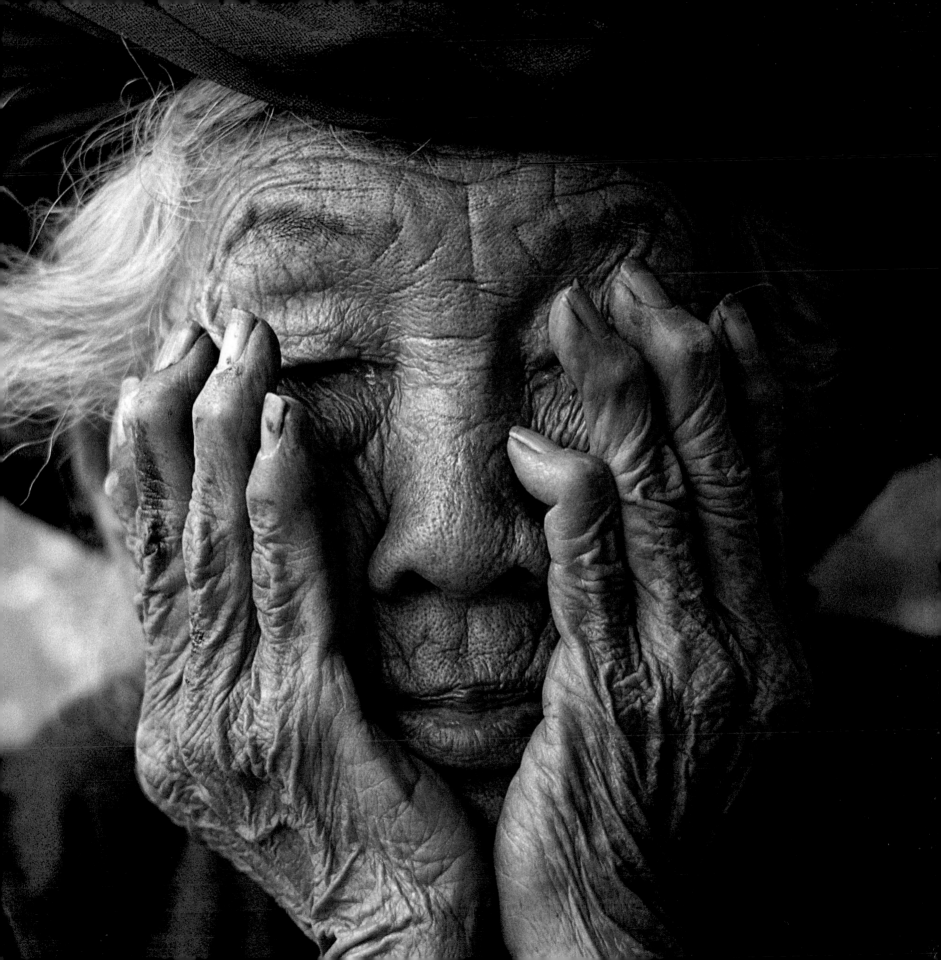

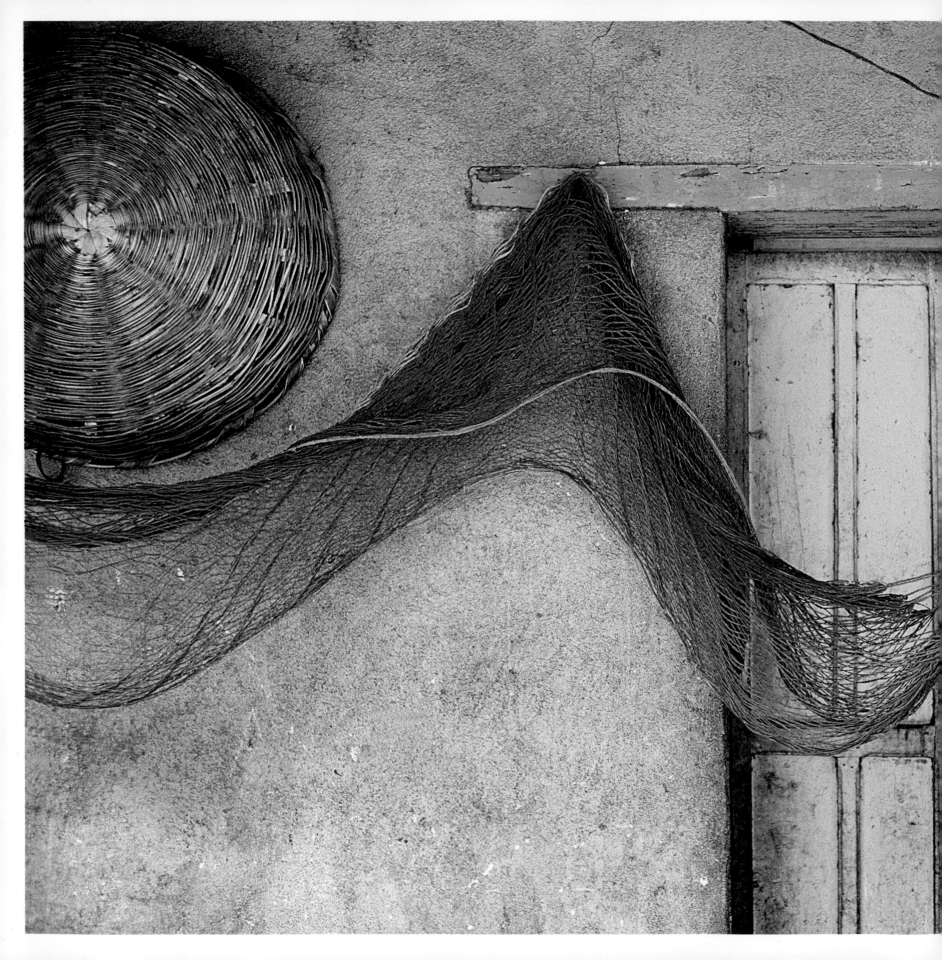

*Life, or its eternal evidence,
is everywhere.*

Ansel Adams

Santa Catarina Palopo, Guatemala

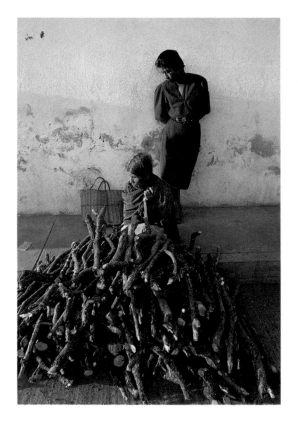

Zimatlán, Mexico

Niger River, Ségou, Mali

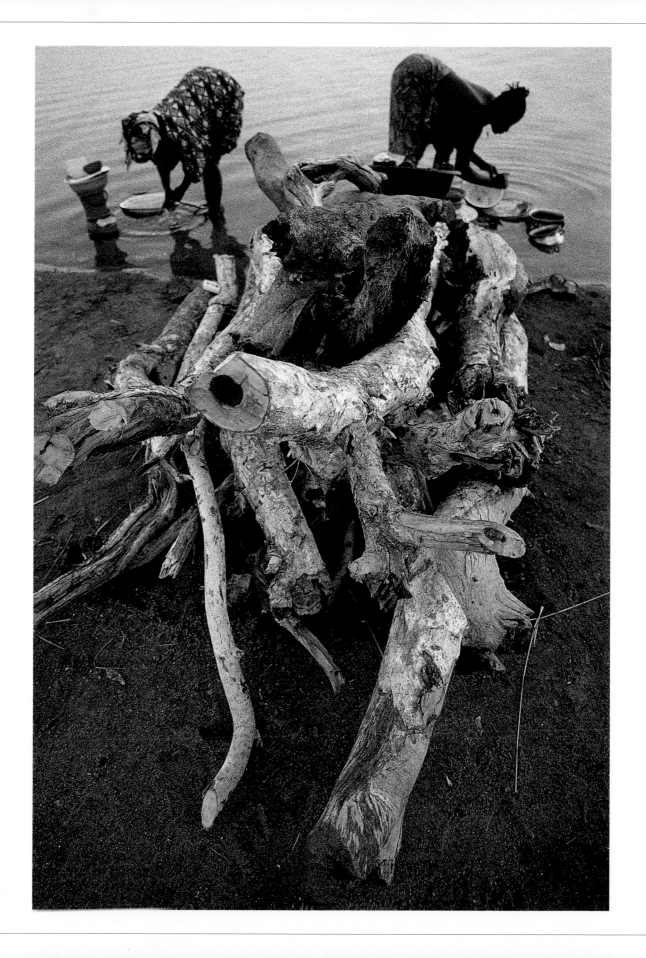

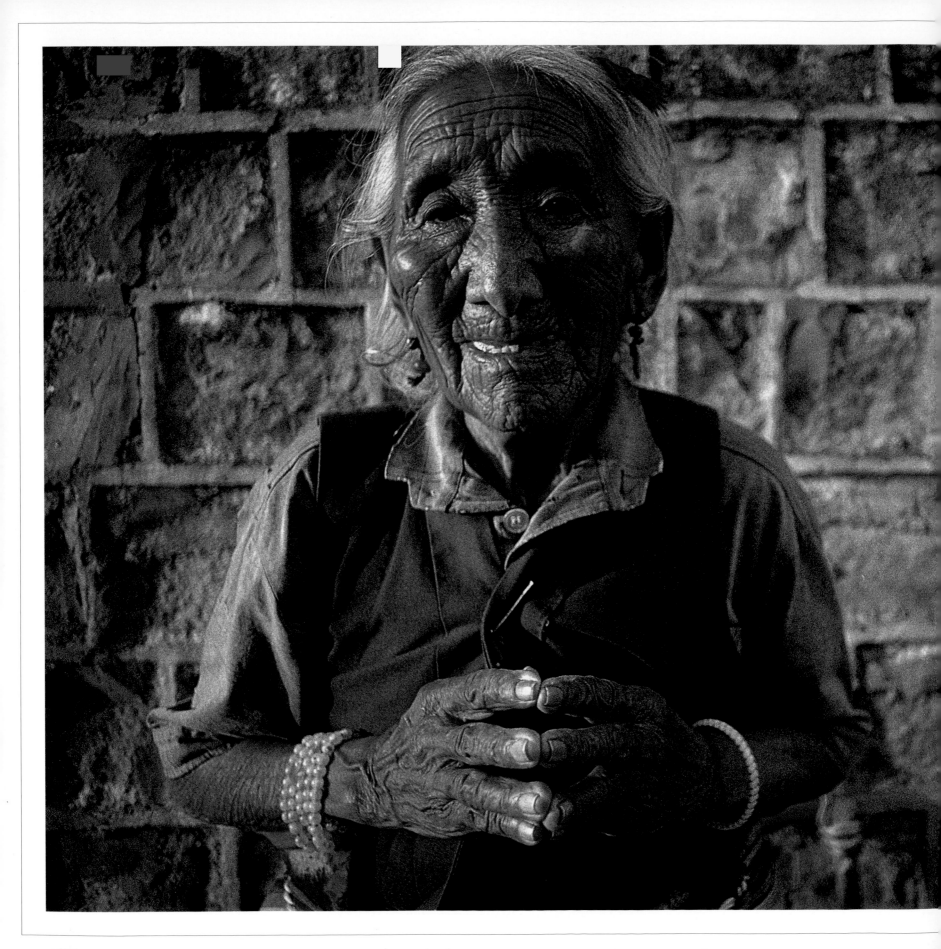

Dharamsala, India

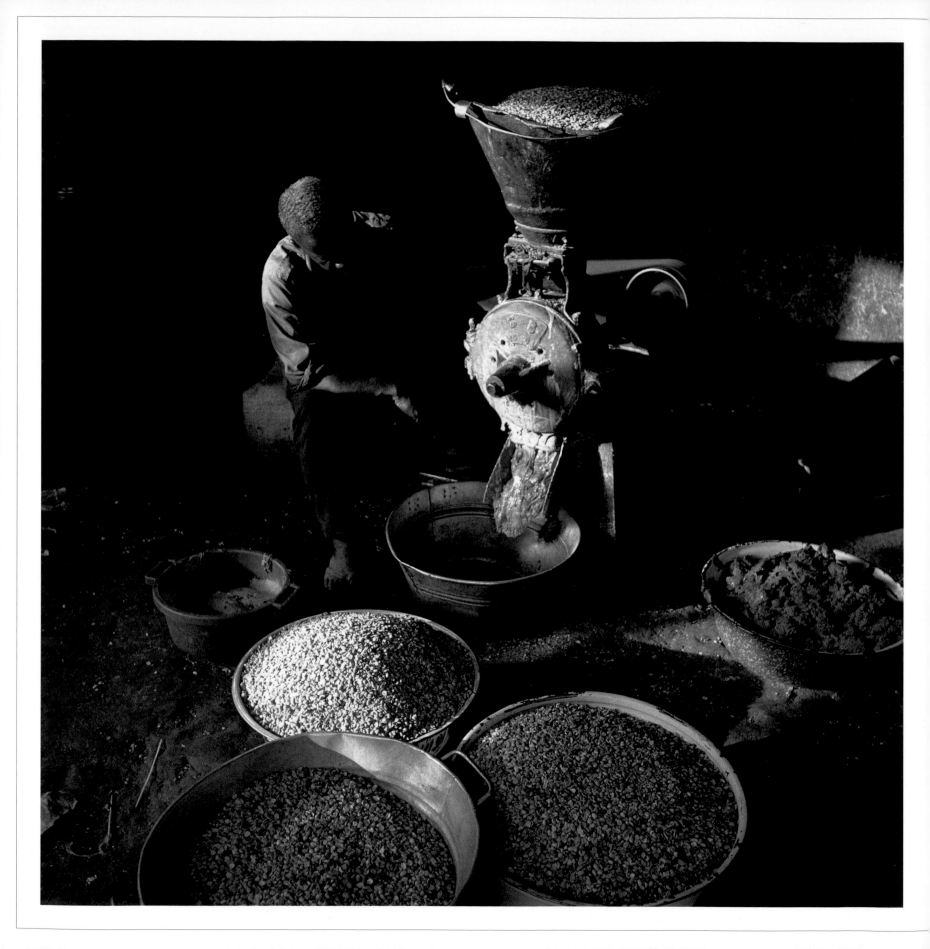

Any man who has a job has a chance.

Elbert Hubbard

Ségou, Mali

Dubrovnik, Croatia

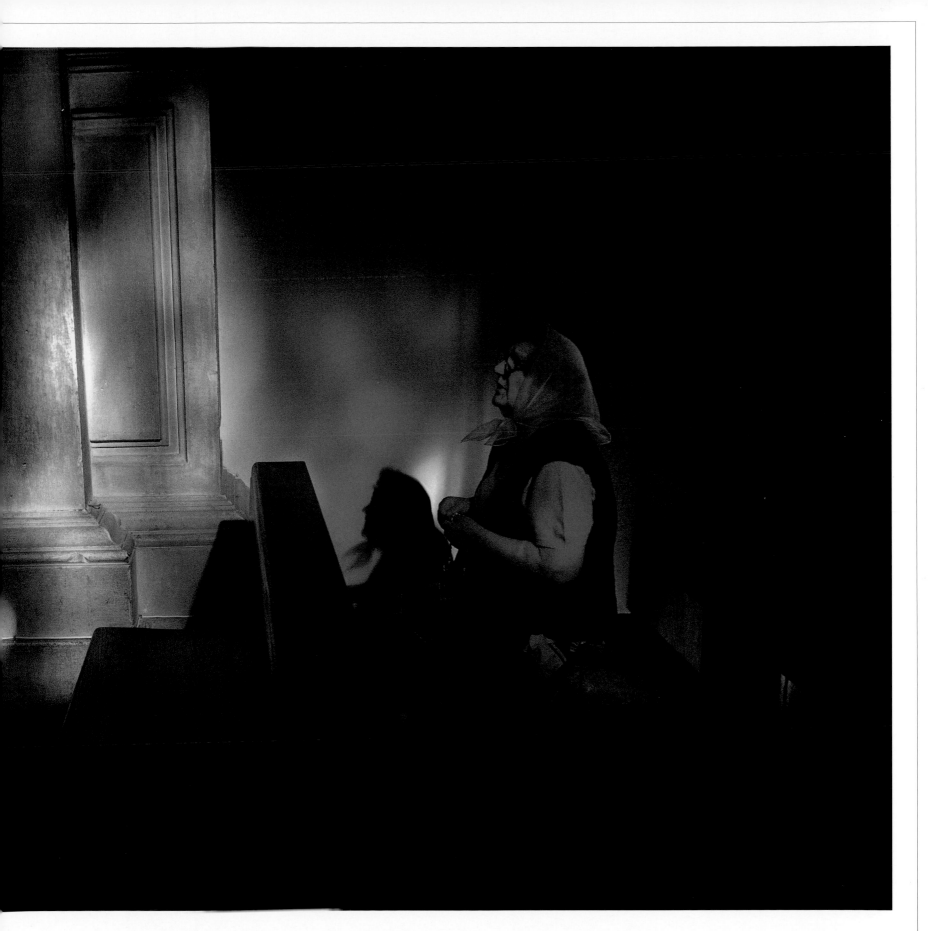

Dali, China

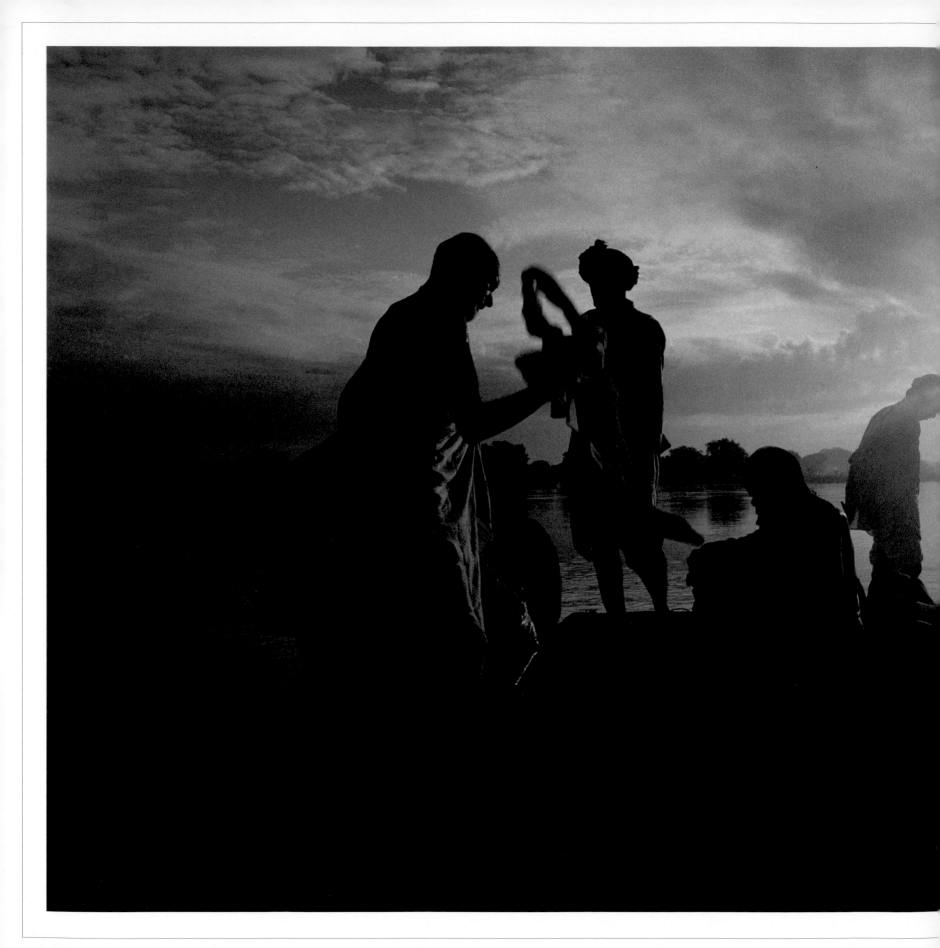

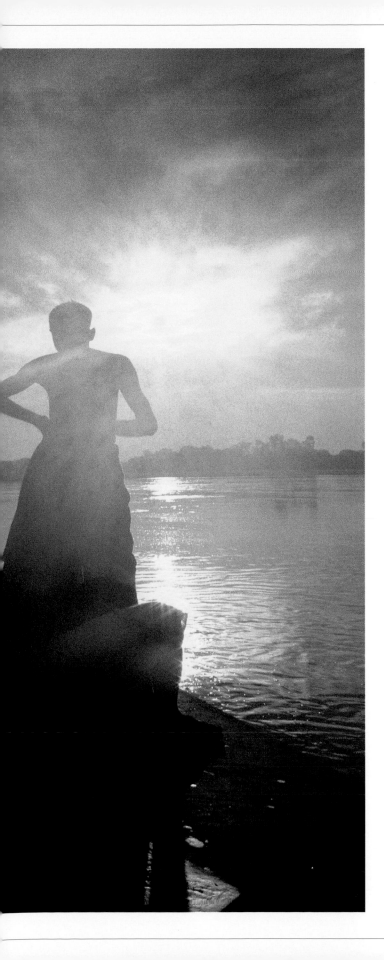

Out of the shadows of night
the world rolls into light.
It is daybreak everywhere.

Longfellow

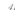

Yamuna River, Mathura, India

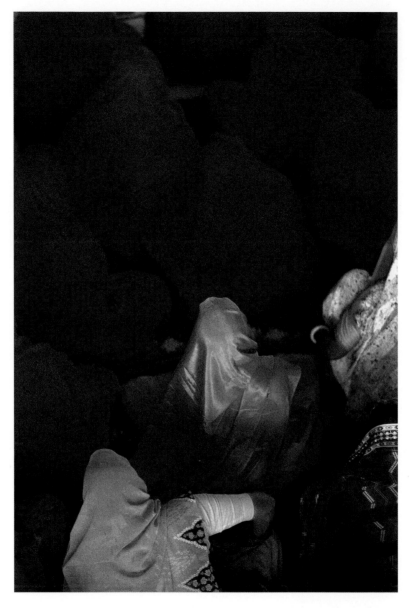

Bhuj, India

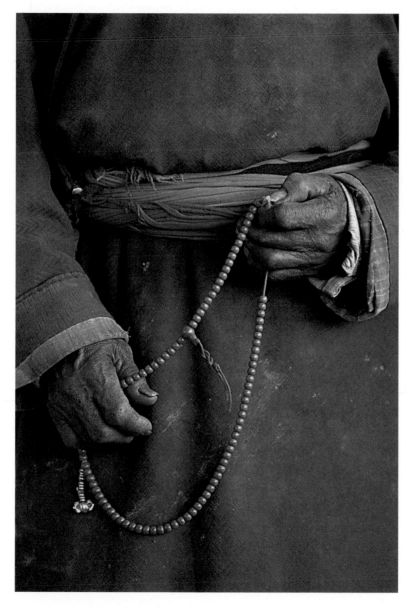

Leh, Ladakh, India

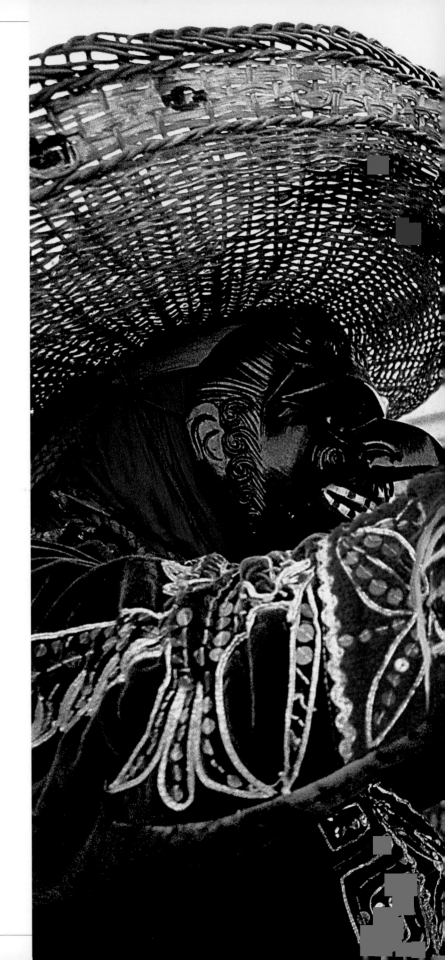

Joyabaj, Guatemala

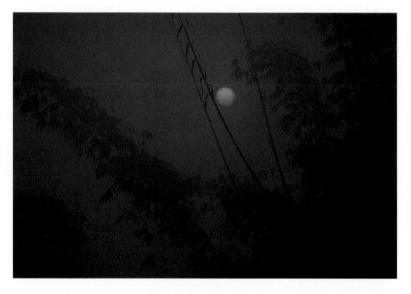

Menghai, China

Baini, China

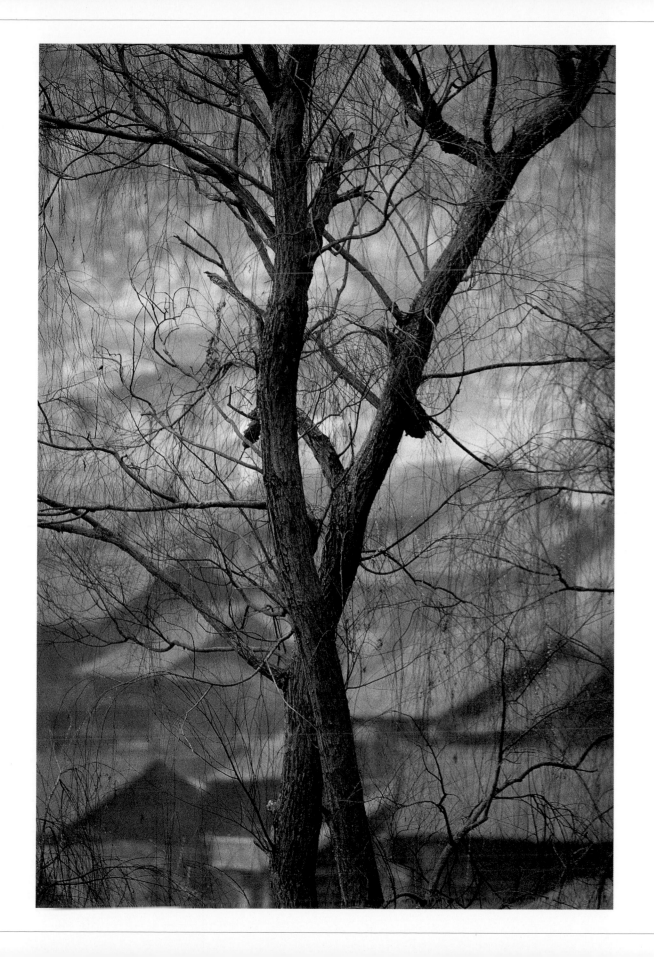

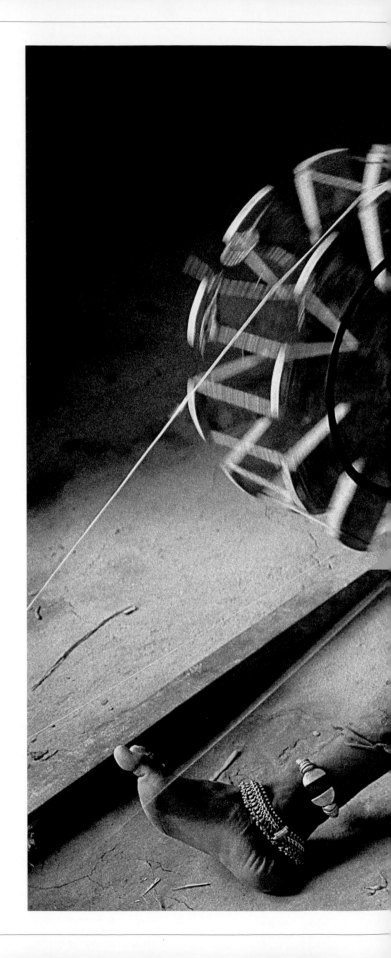

Work is love made visible.

Kahlil Gibran

Jaisalmer, India

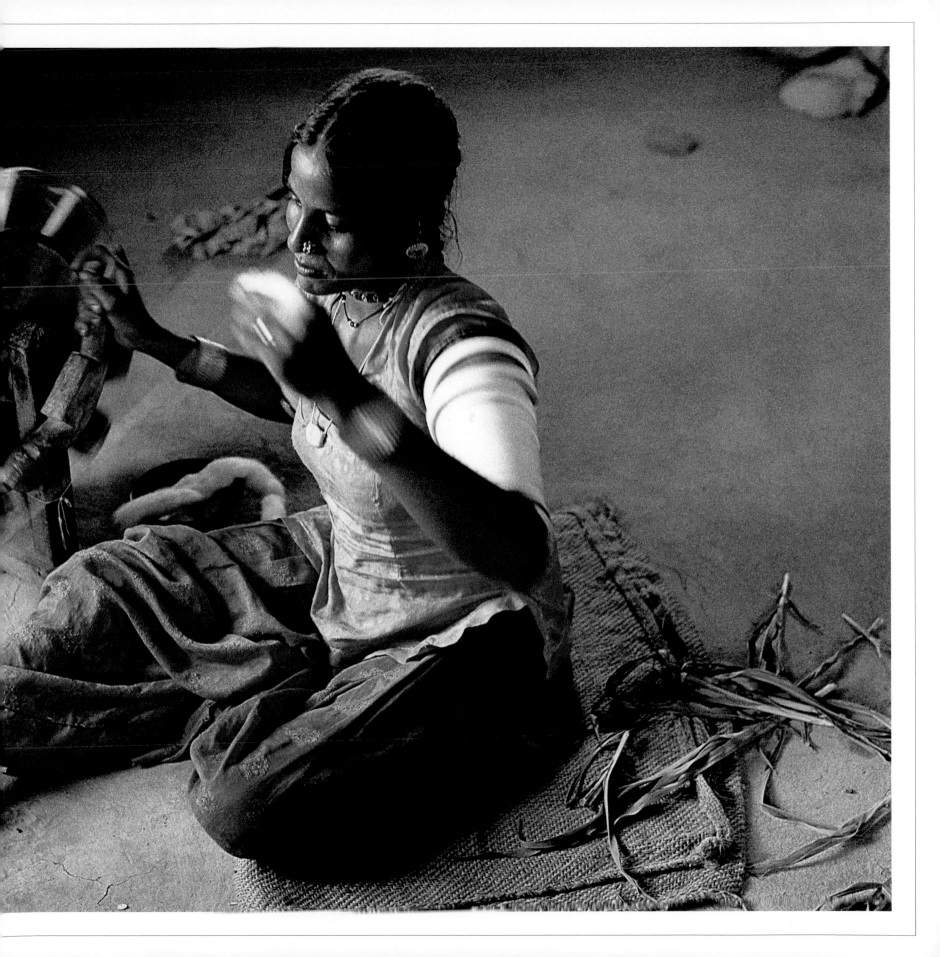

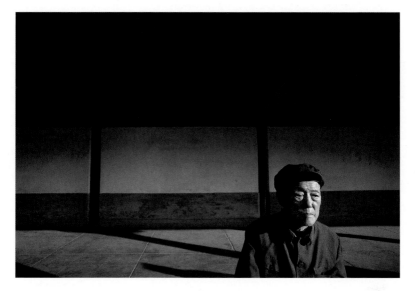

Beijing, China

Dali, China

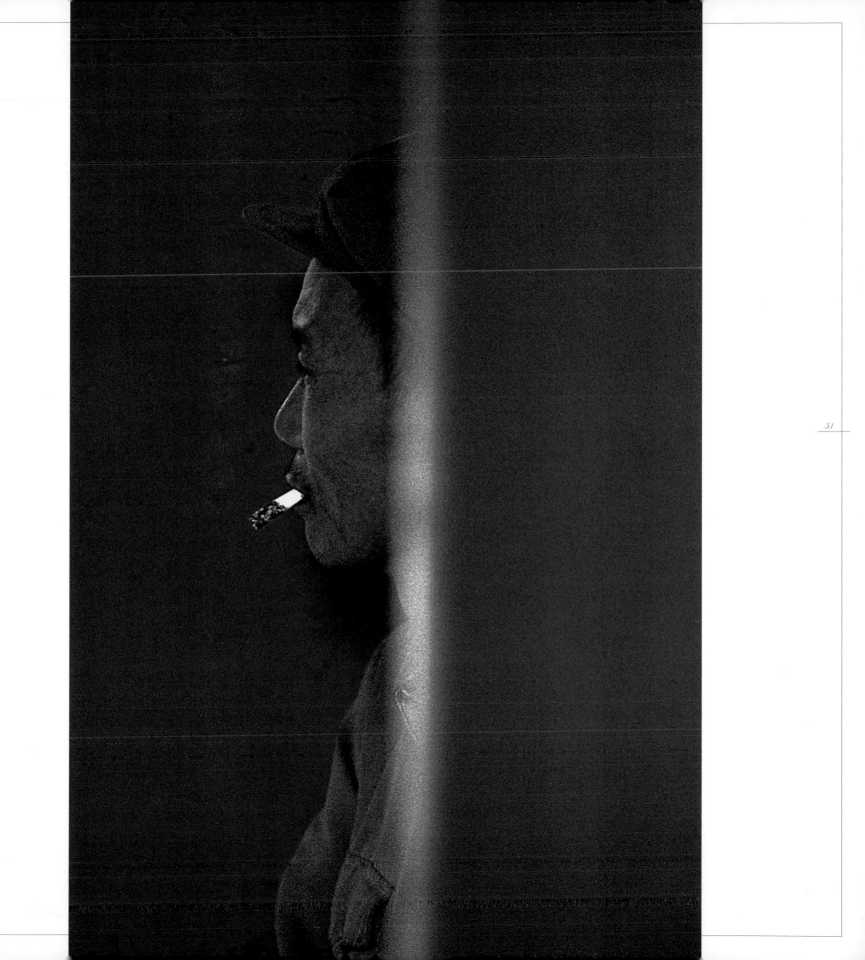

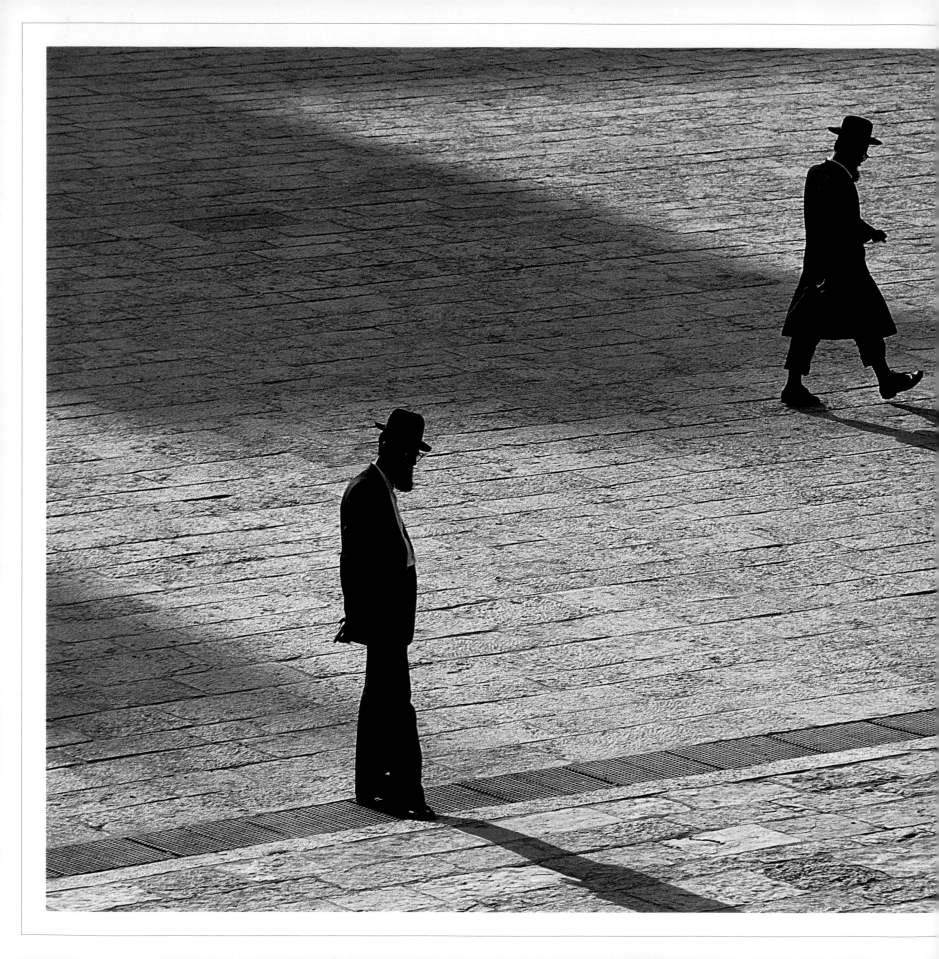

Jerusalem, Israel

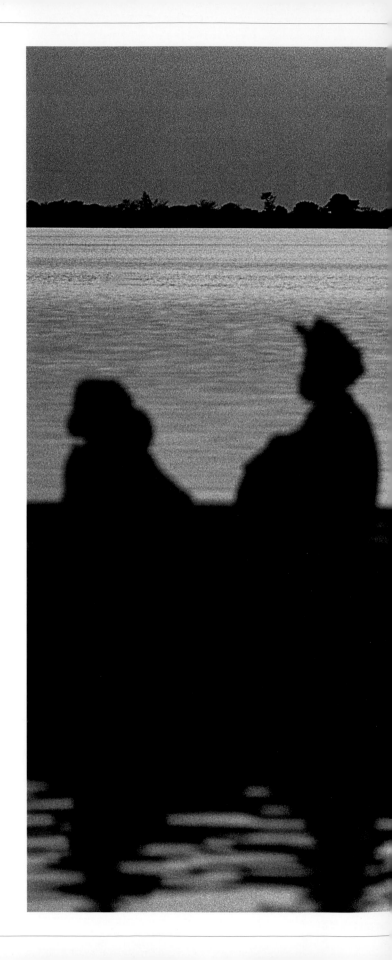

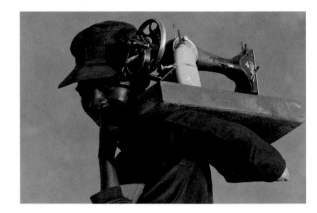

Bamako, Mali

Niger River, Ségou, Mali

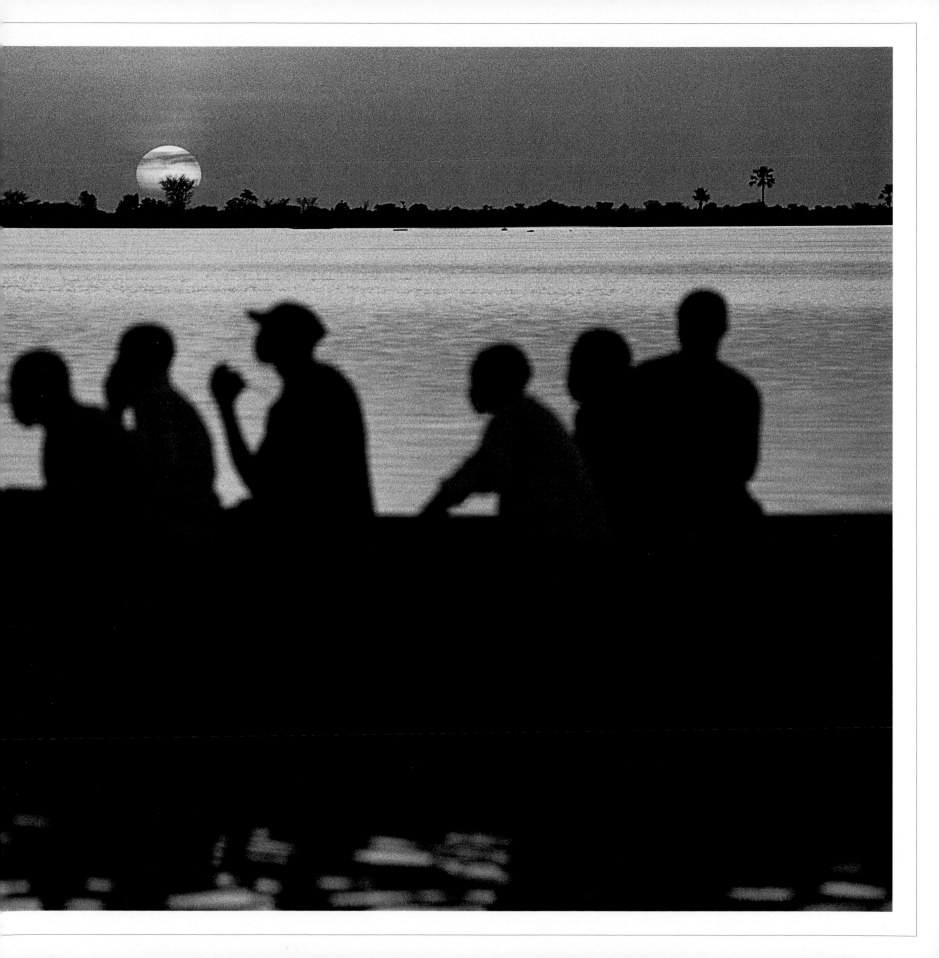

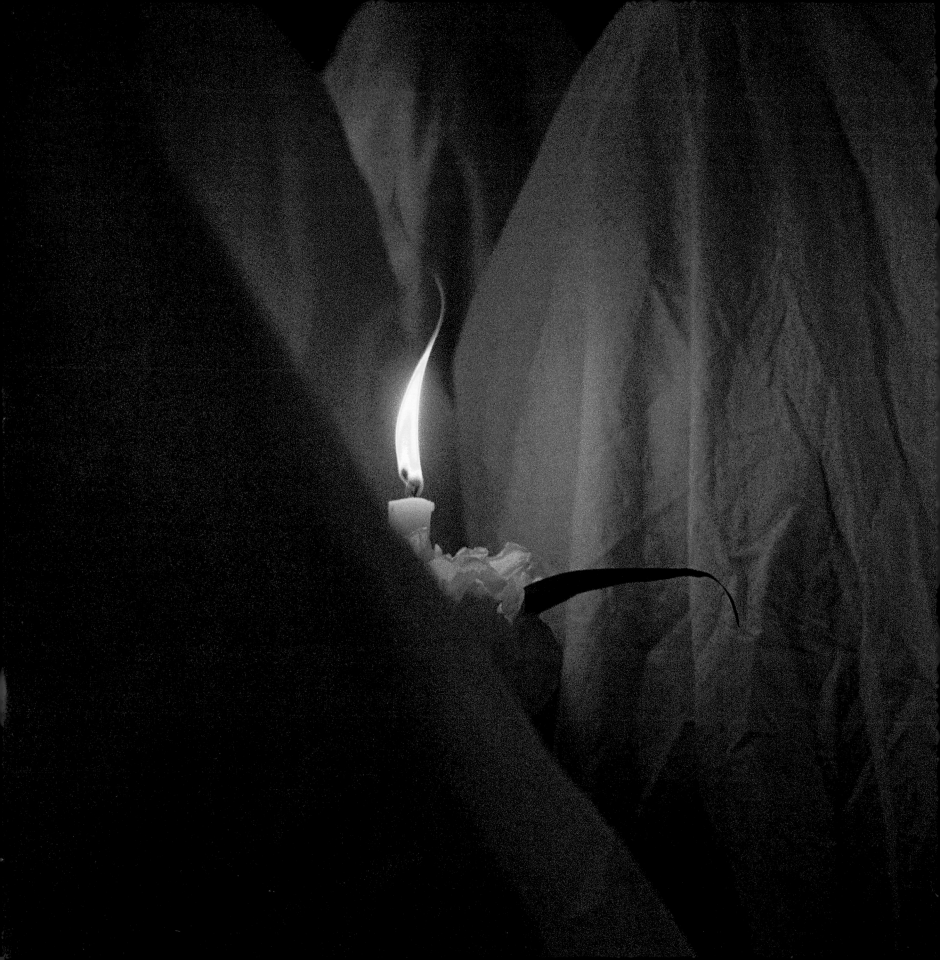

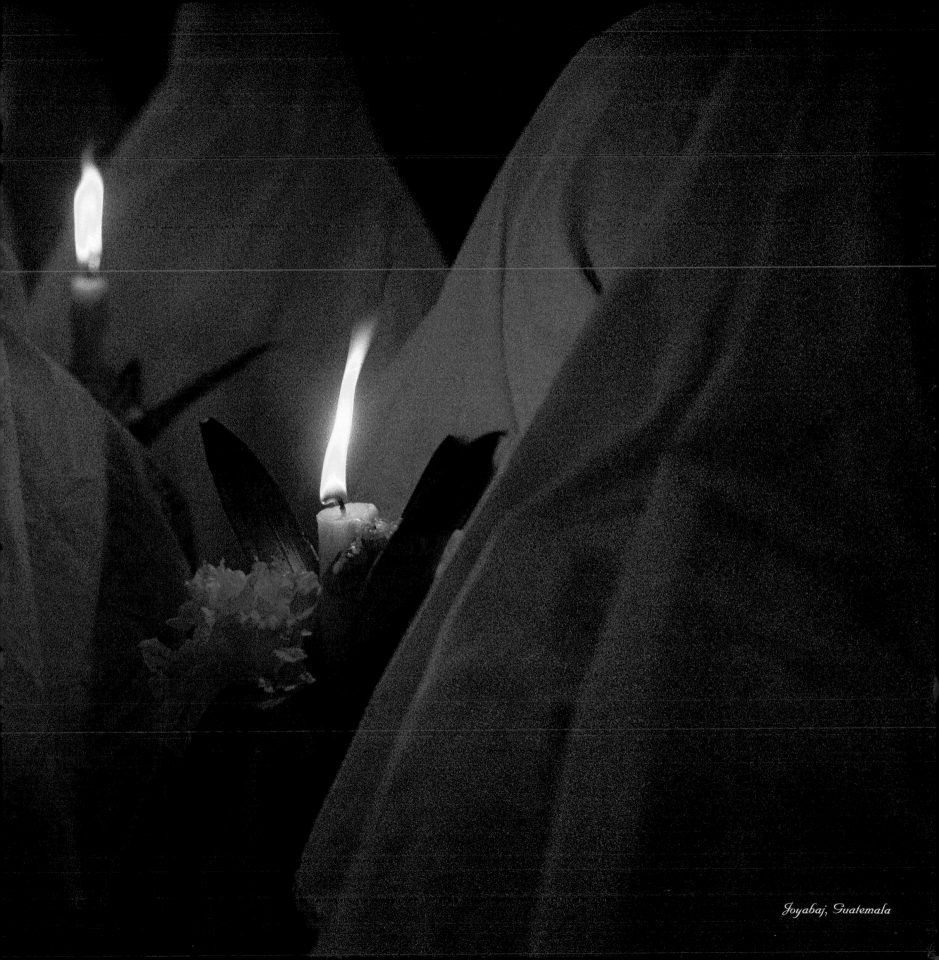

Joyabaj, Guatemala

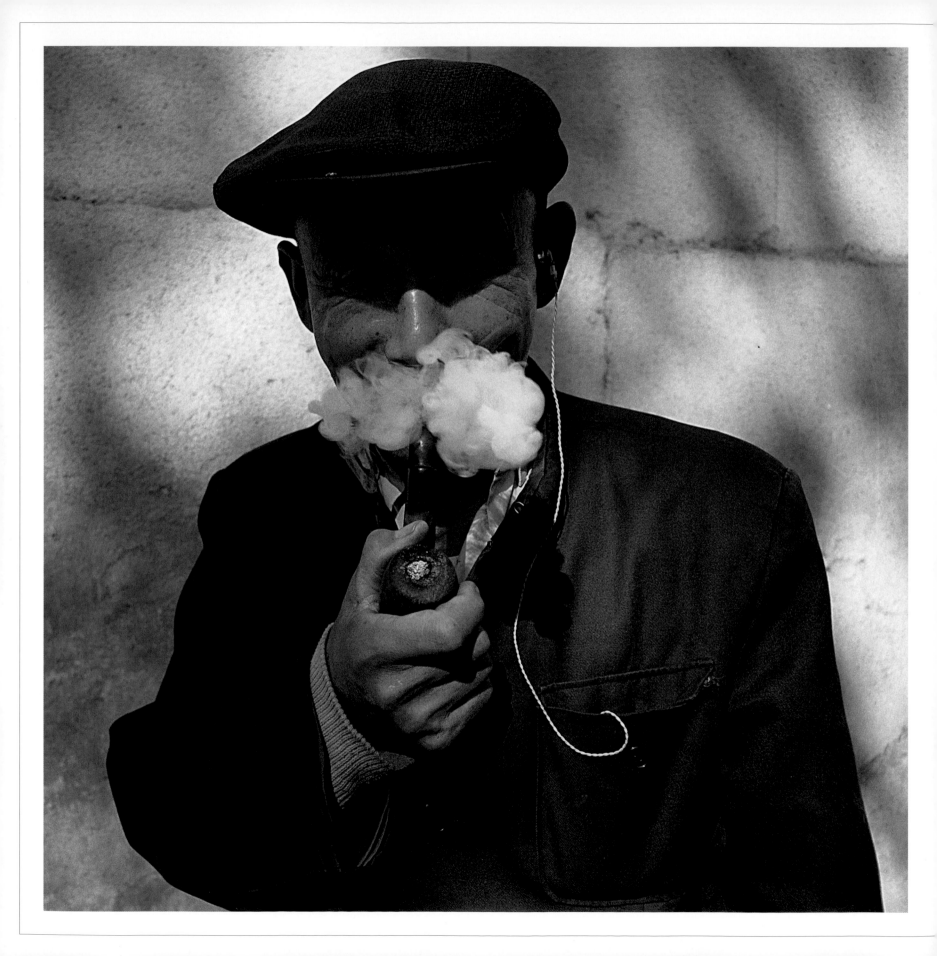

God must love the common man, he made so many of them.

Abraham Lincoln

Bejing, China

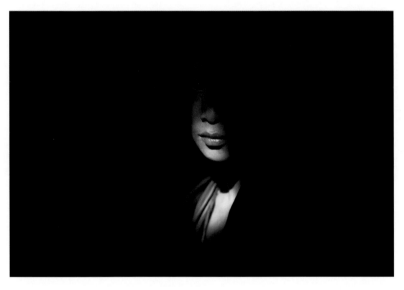

Menghai, China

San Juan La Laguna, Guatemala

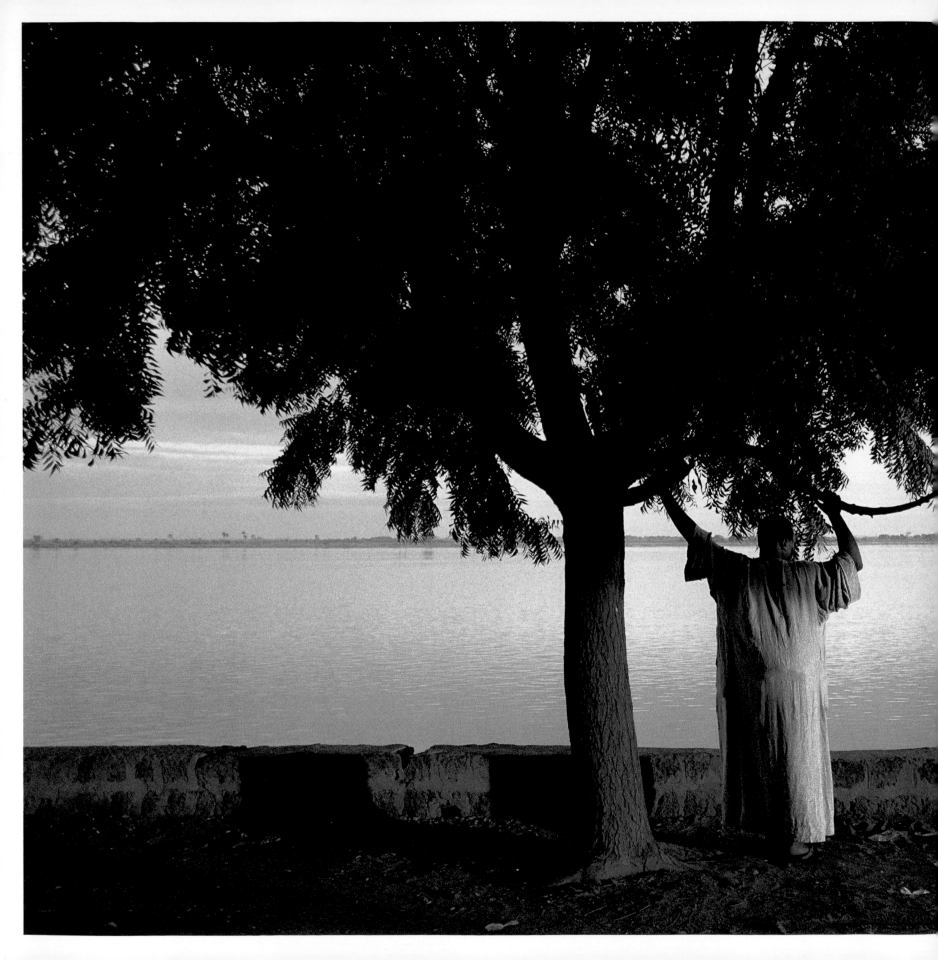

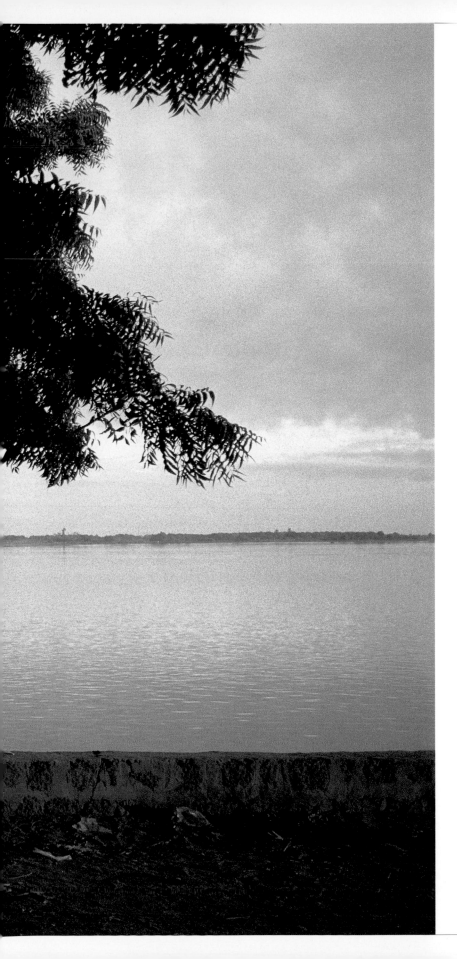

Niger River, Ségou, Mali

Every child comes with the message that God is not yet discouraged of man.

Tagore

San, Mali

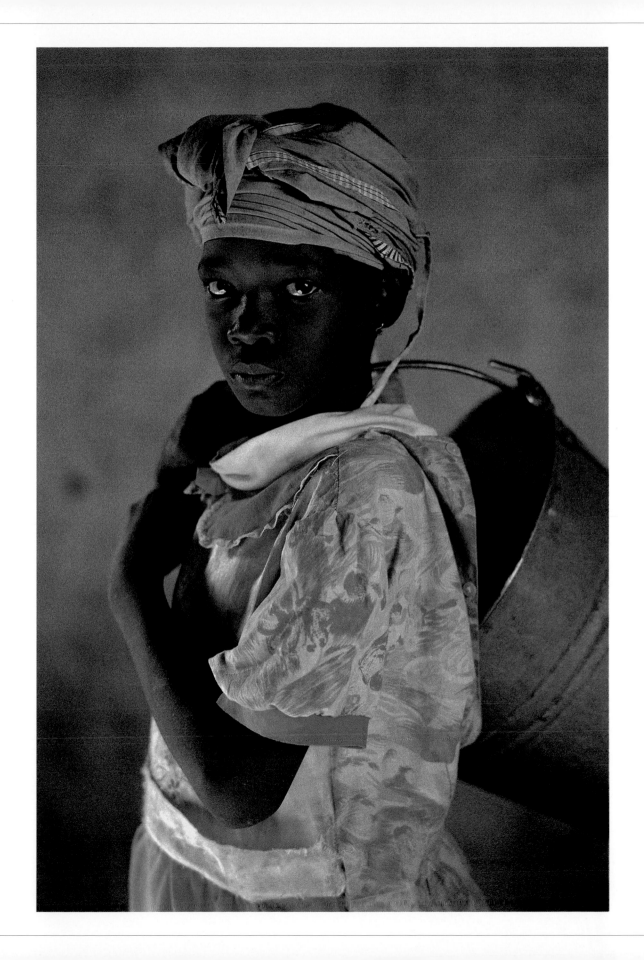

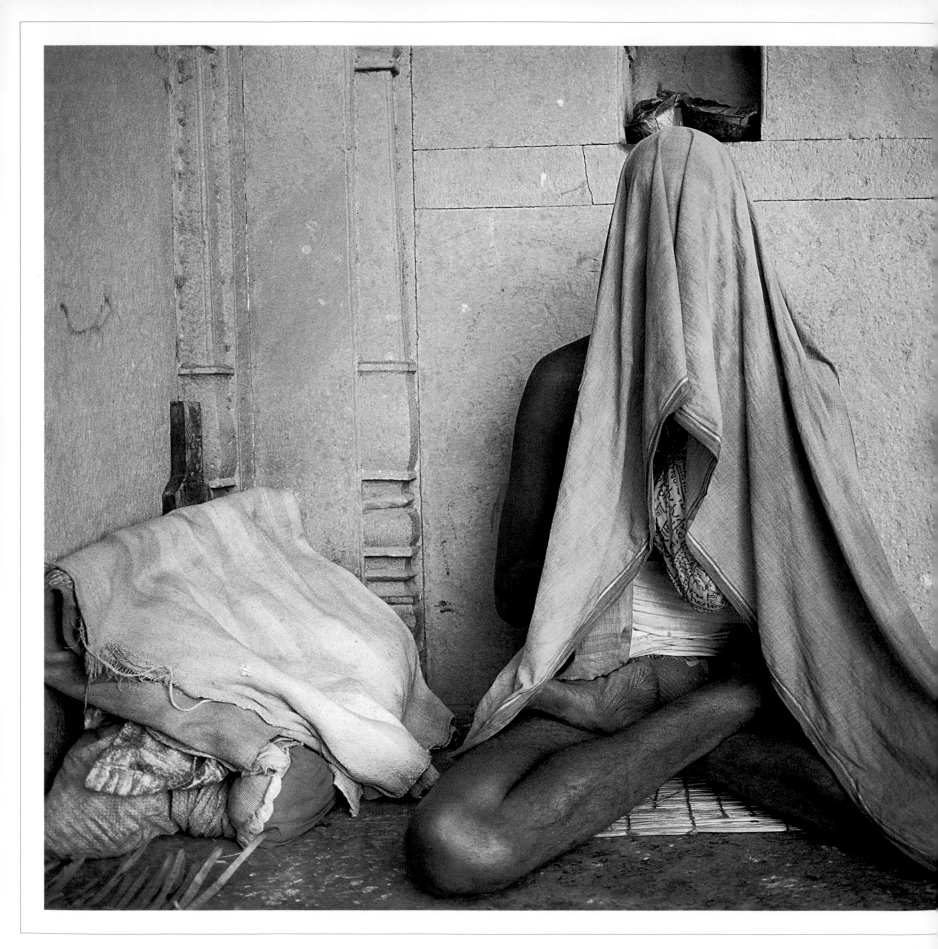

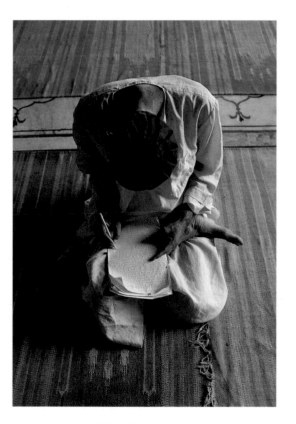

New Delhi, India

Mathura, India

Shanghai, China

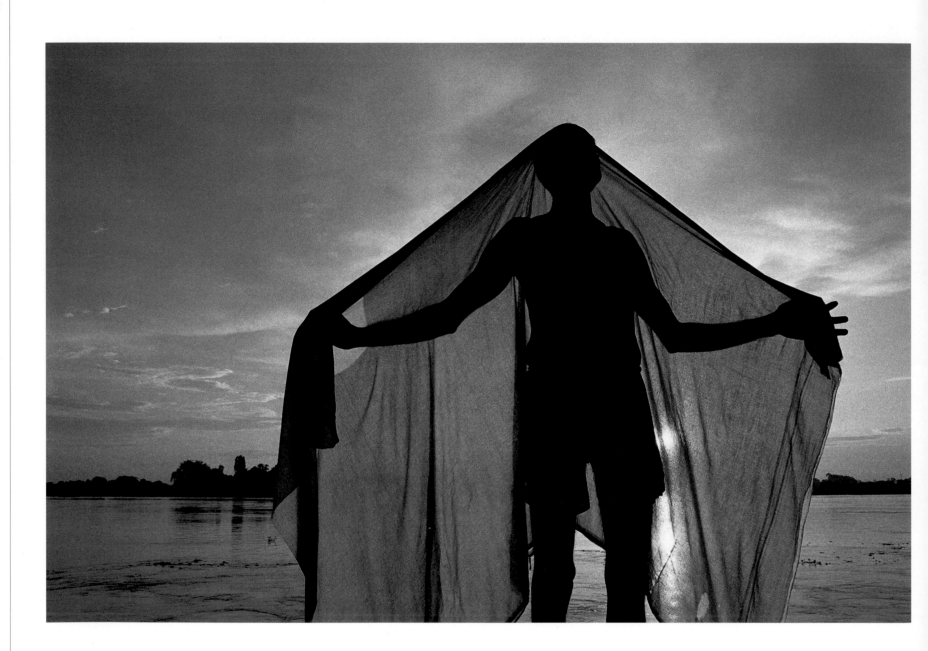

Man is, properly speaking, based on hope;
he has no other possession but hope.

Thomas Carlyle

Yamuna River, Mathura, India

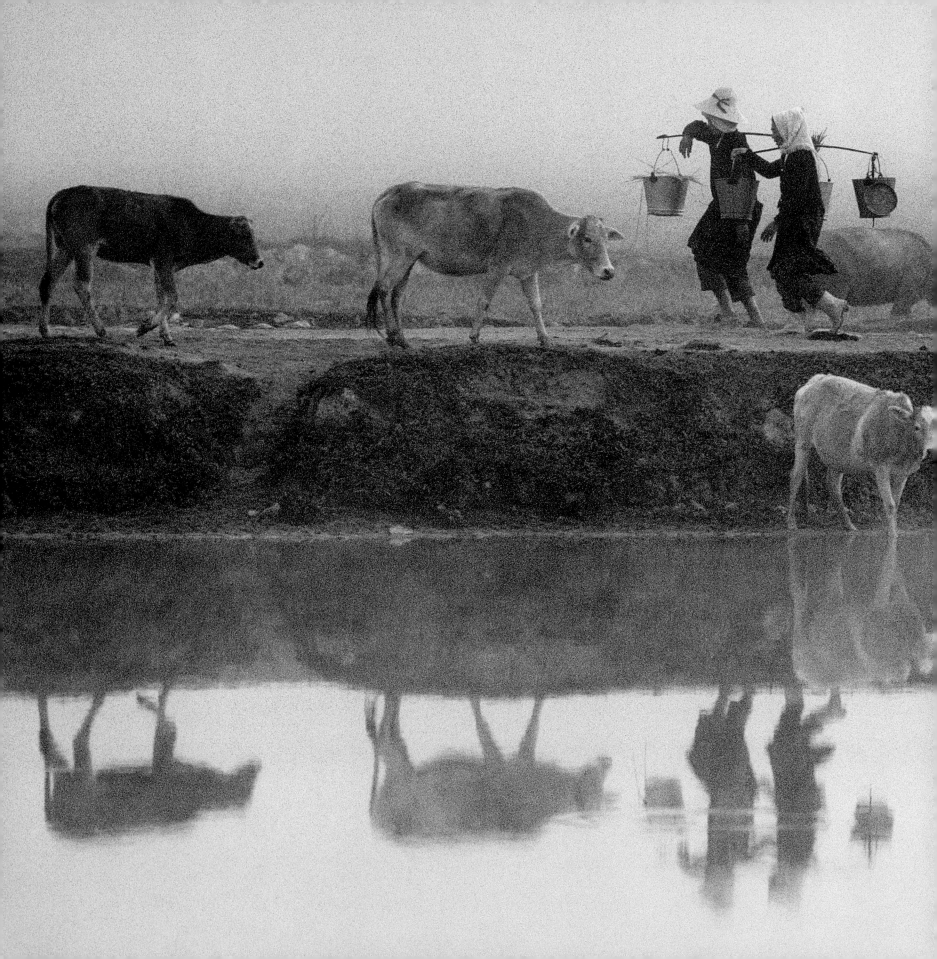

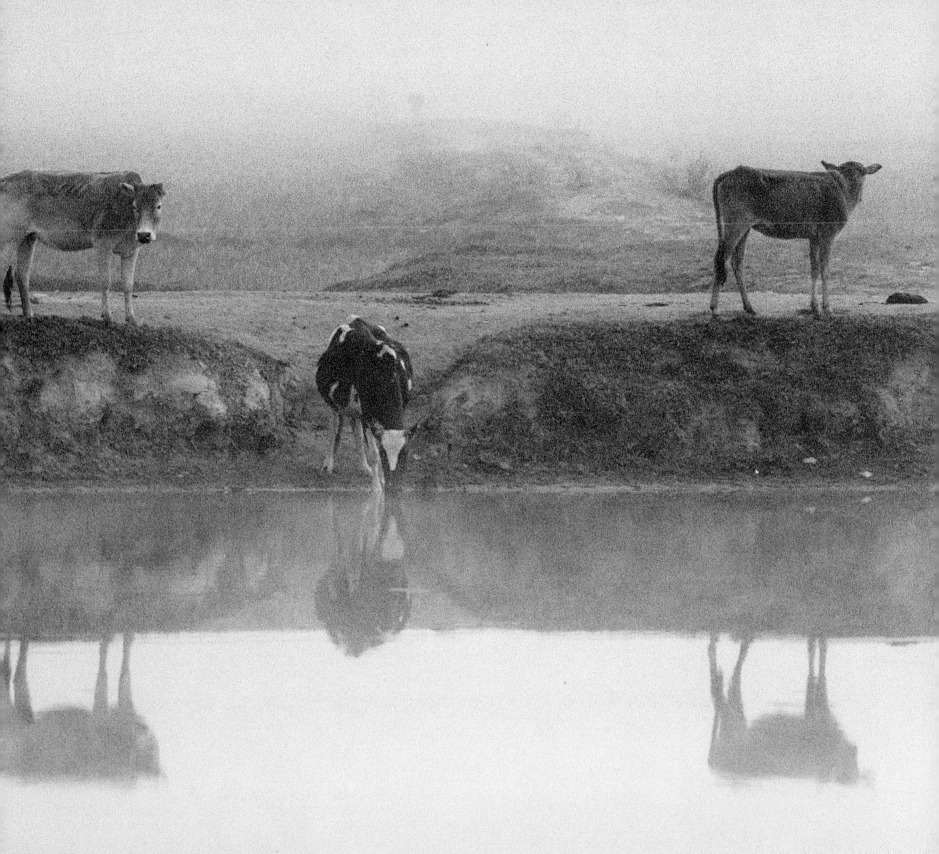

Menghun, China

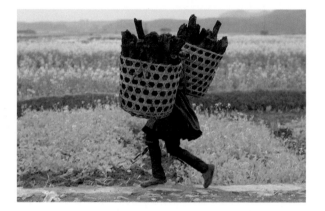

Rongjian, China

Lake Atitlán, Santiago Atitlán, Guatemala

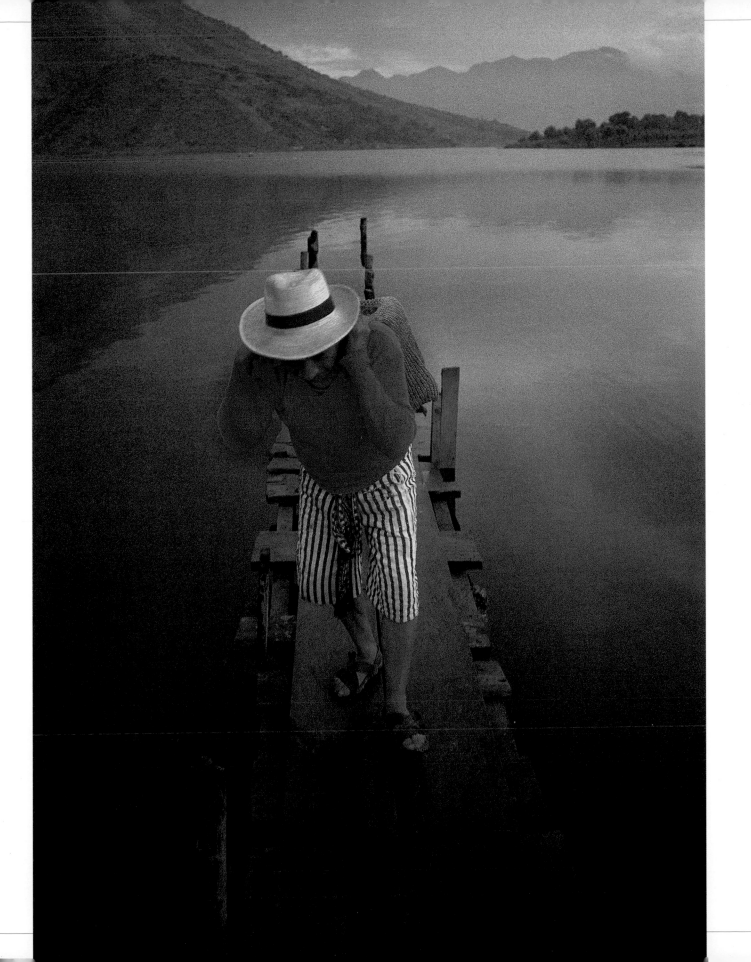

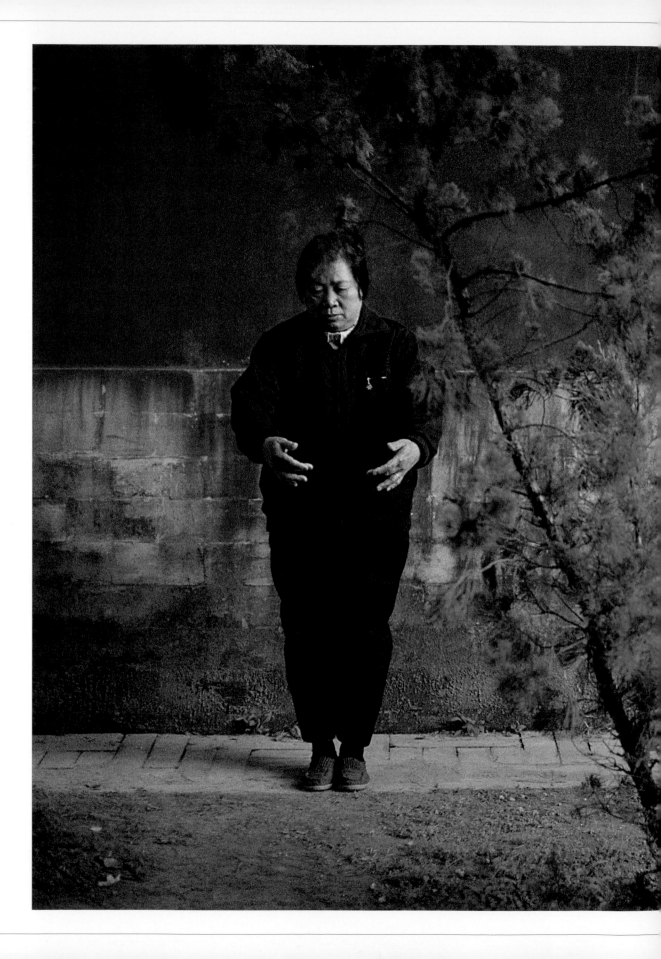

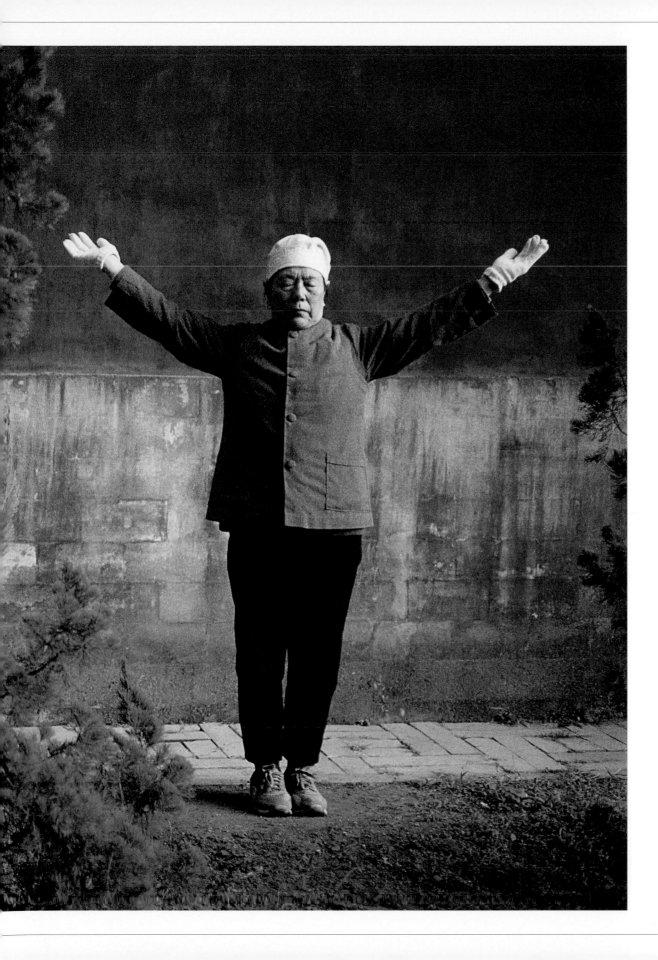

Beijing, China

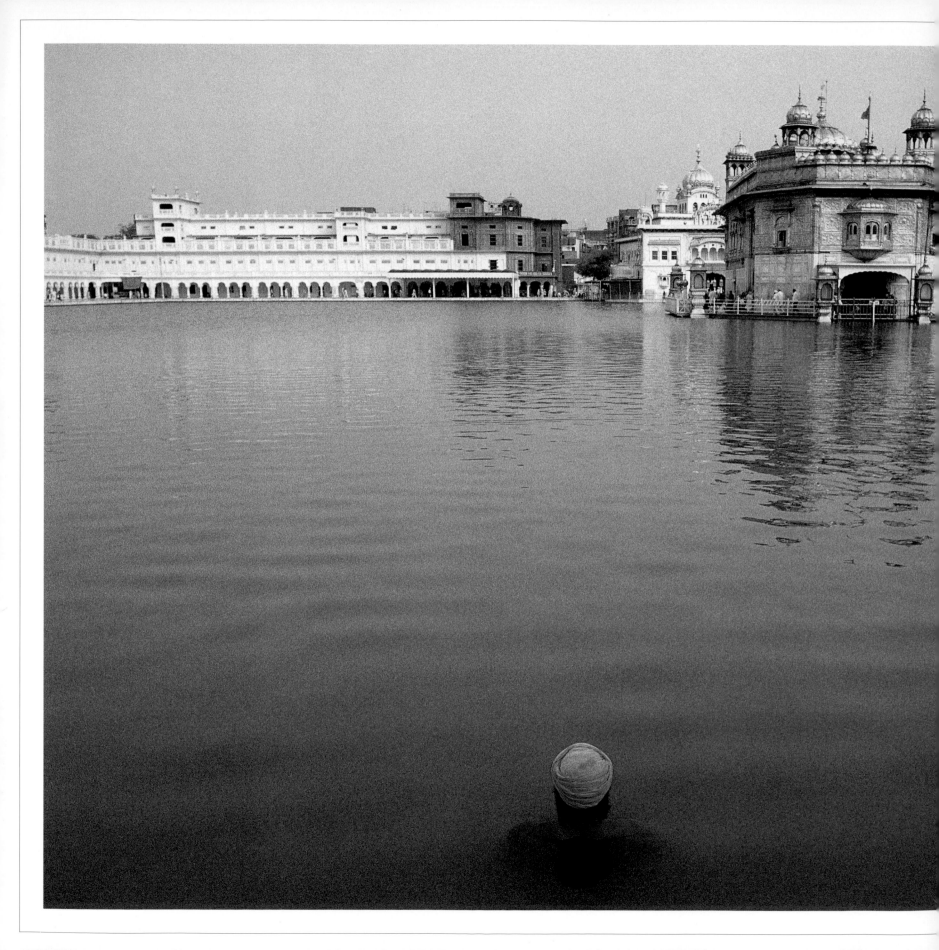

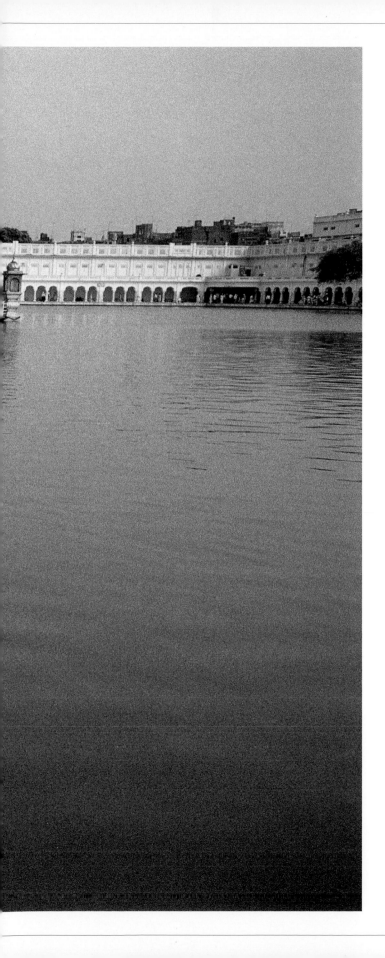

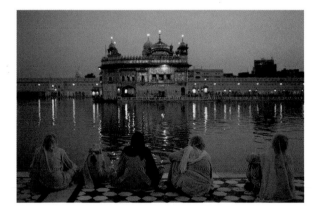

Amritsar, India

There is a great difference between traveling
to see countries or to see people.

Rosseau

Joyabaj, Guatemala

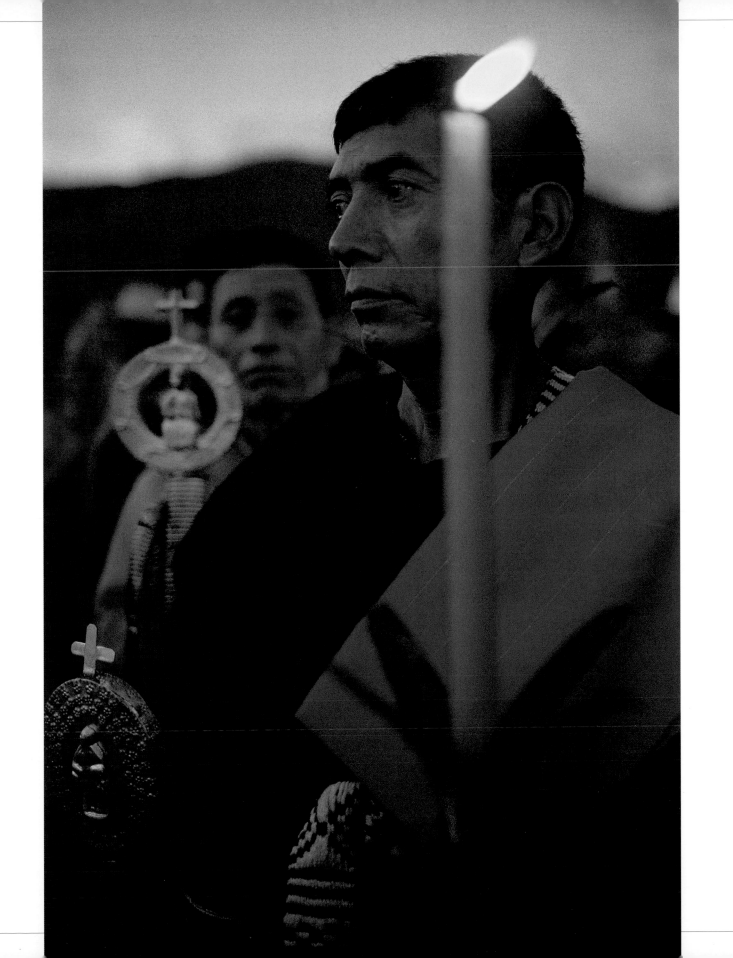

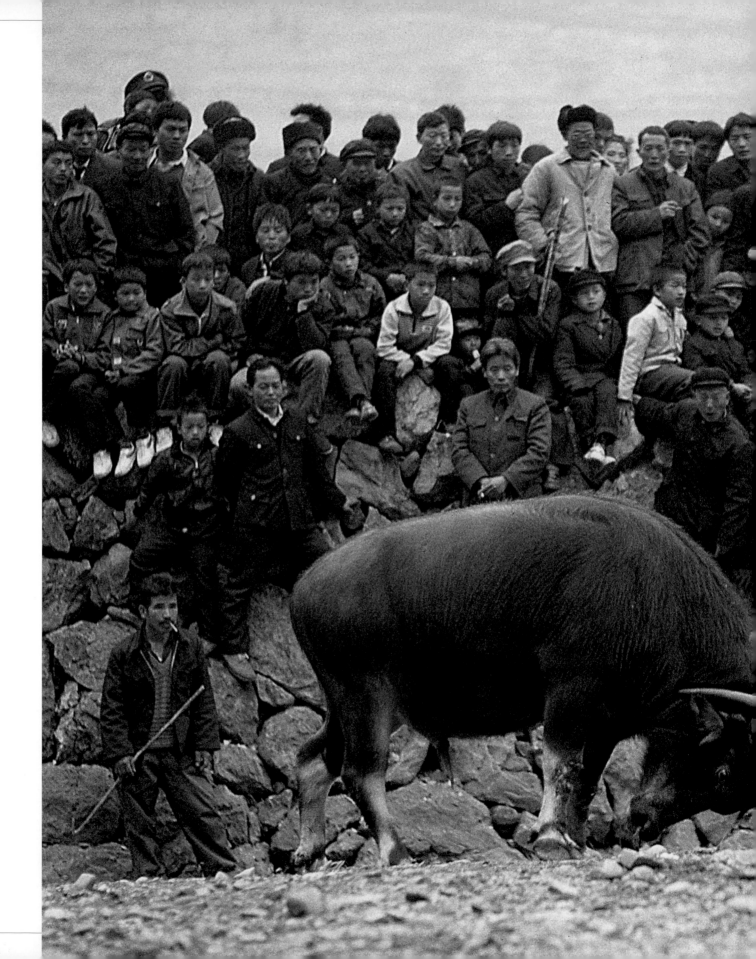

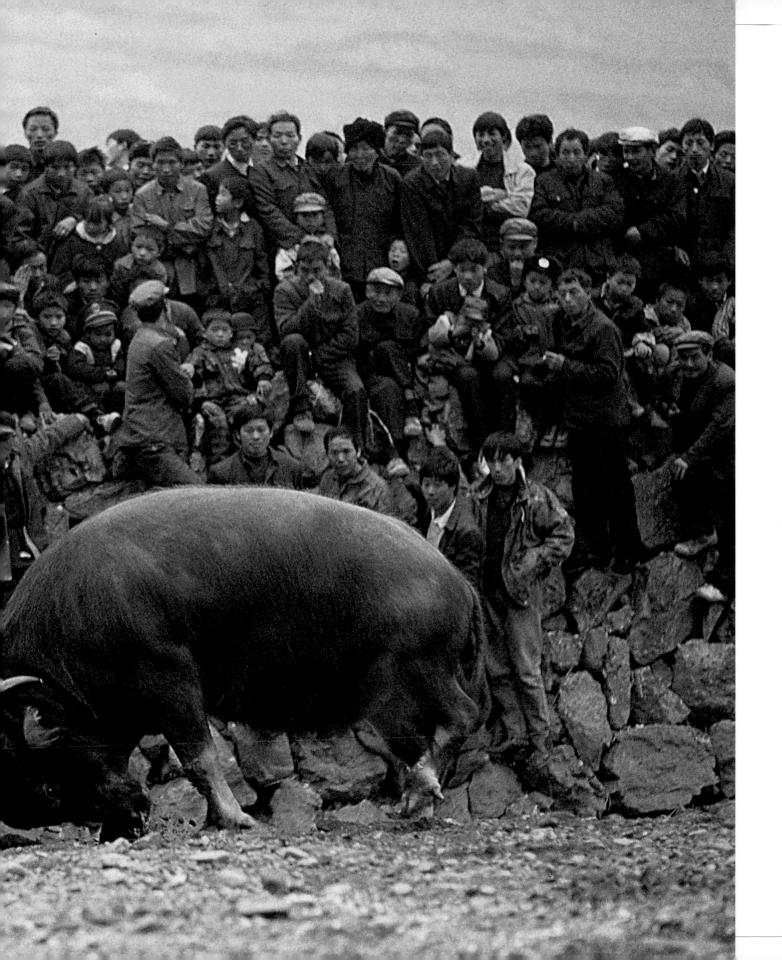

Baini, China

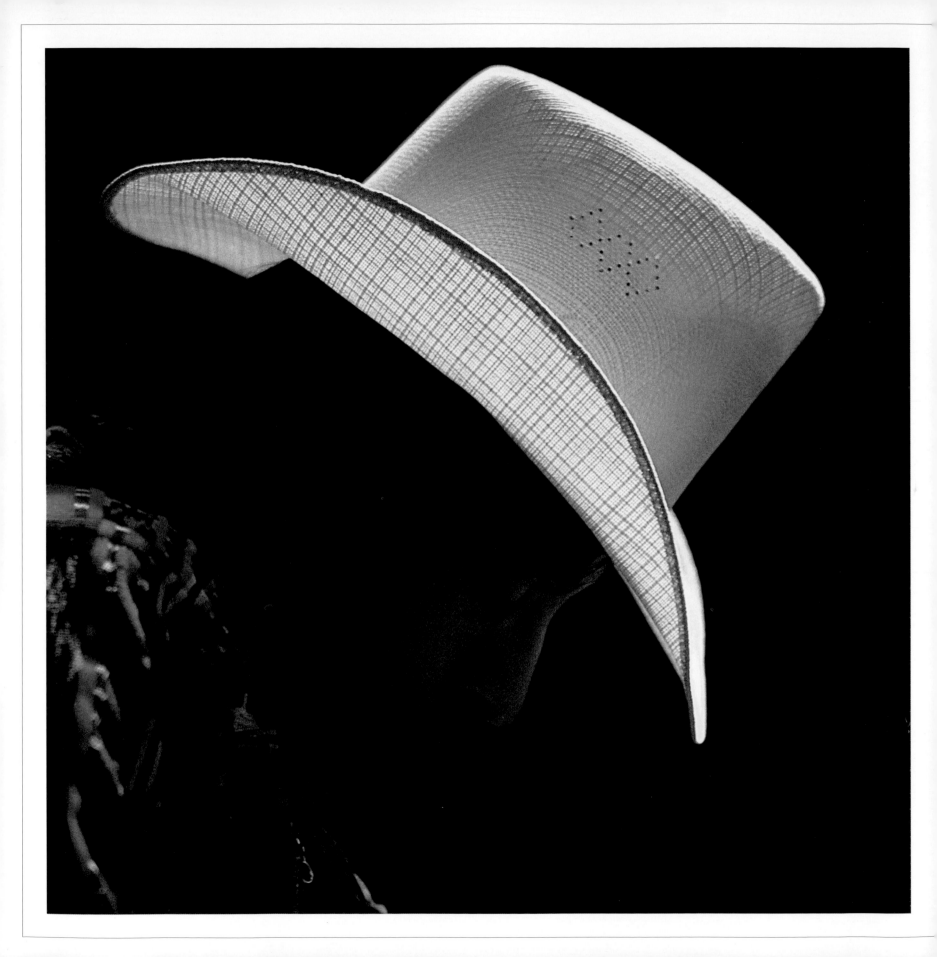

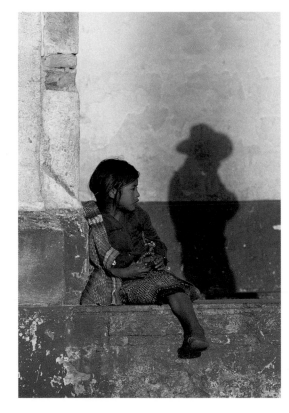

Momostenango, Guatemala

We have come out of the time when obedience, the acceptance of discipline, intelligent courage and resolution were most important, into the more difficult time when it is a man's duty to understand his world rather than simply fight for it.

Hemmingway

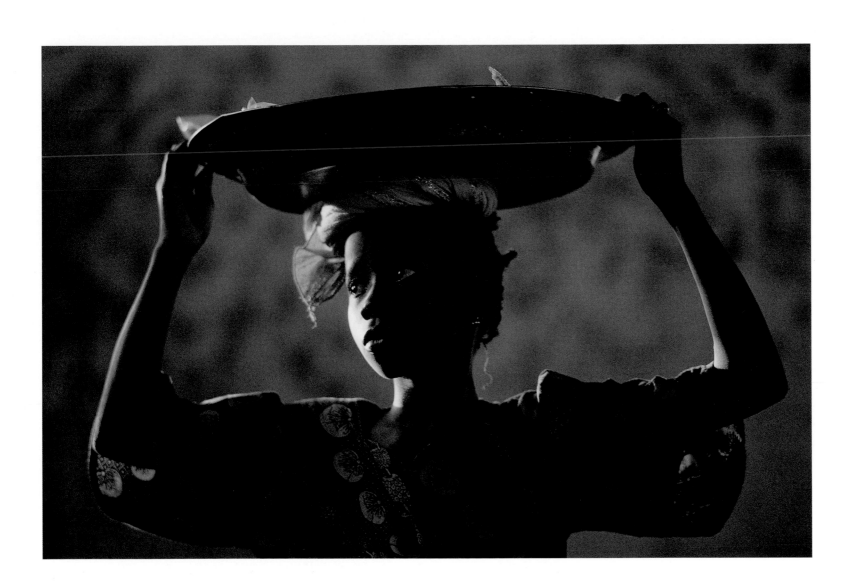

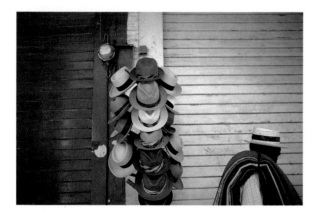

Port-Au-Prince, Haiti

Lijang, China

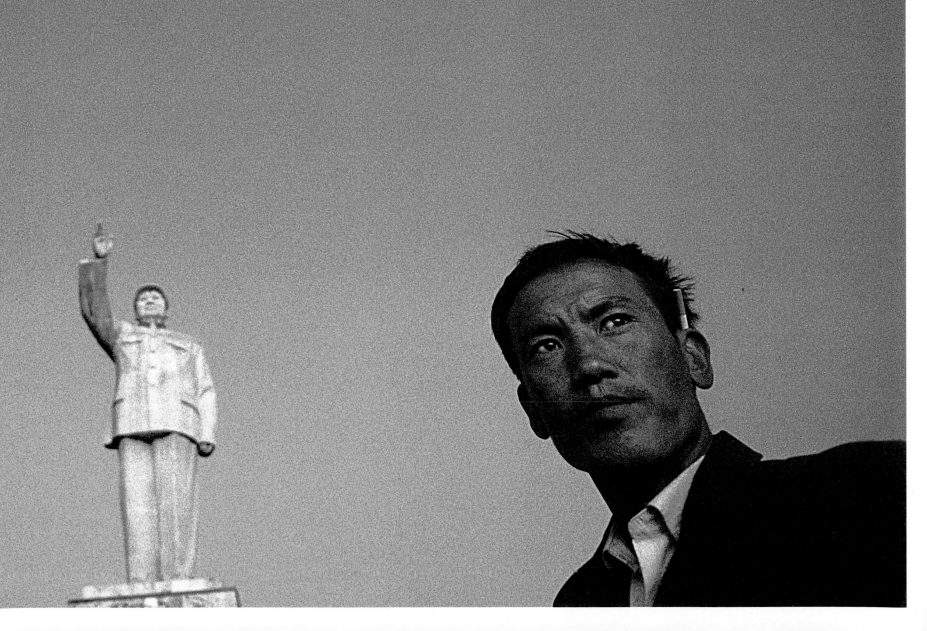

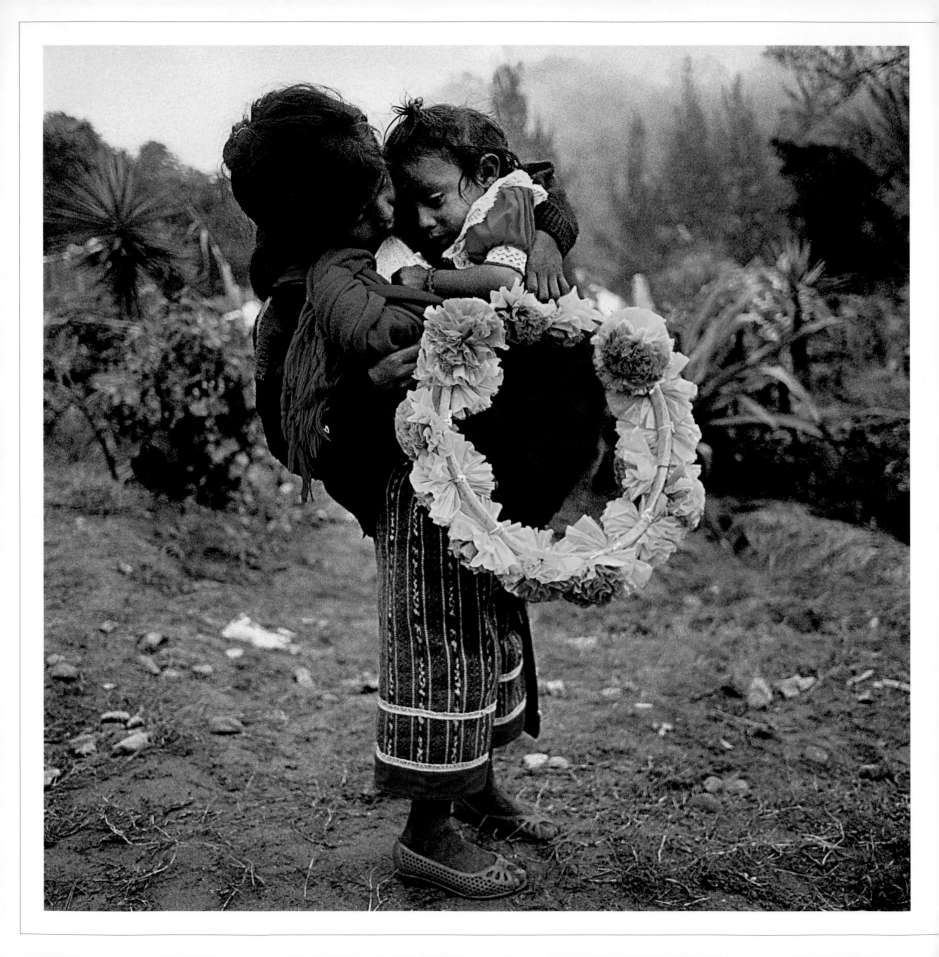

Where children are not, heaven is not.

Charles Swinburne

Sacapulas, Guatemala

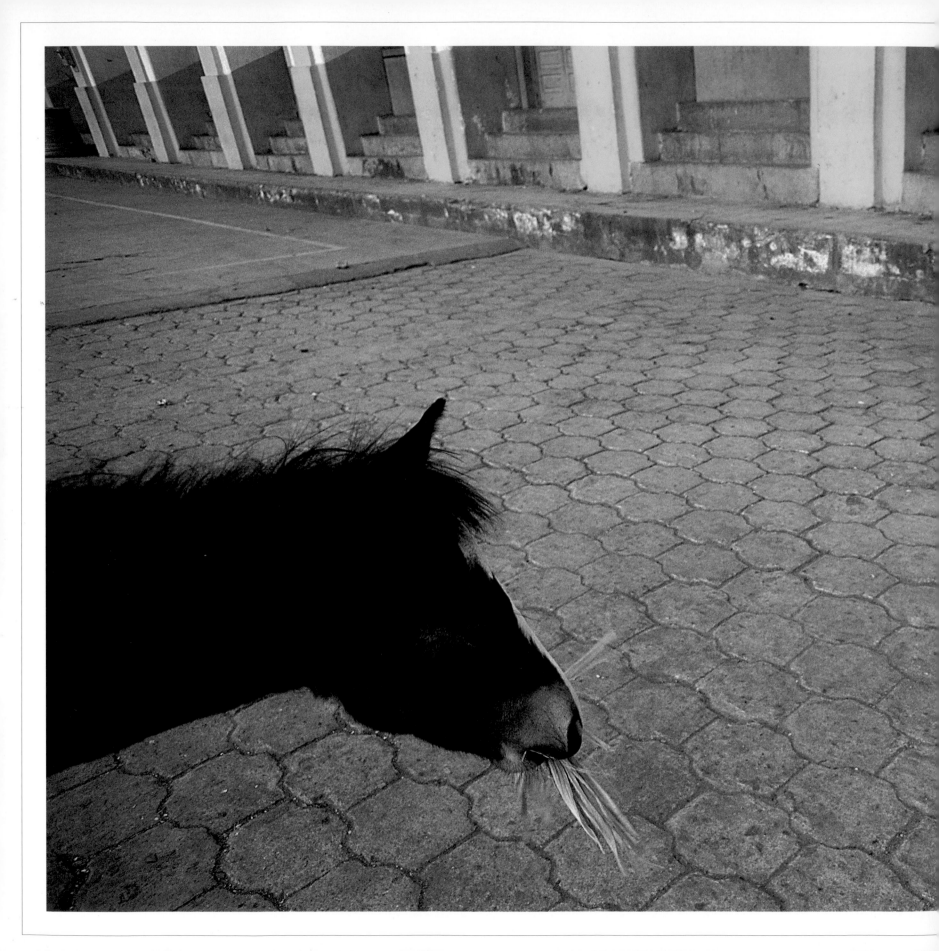

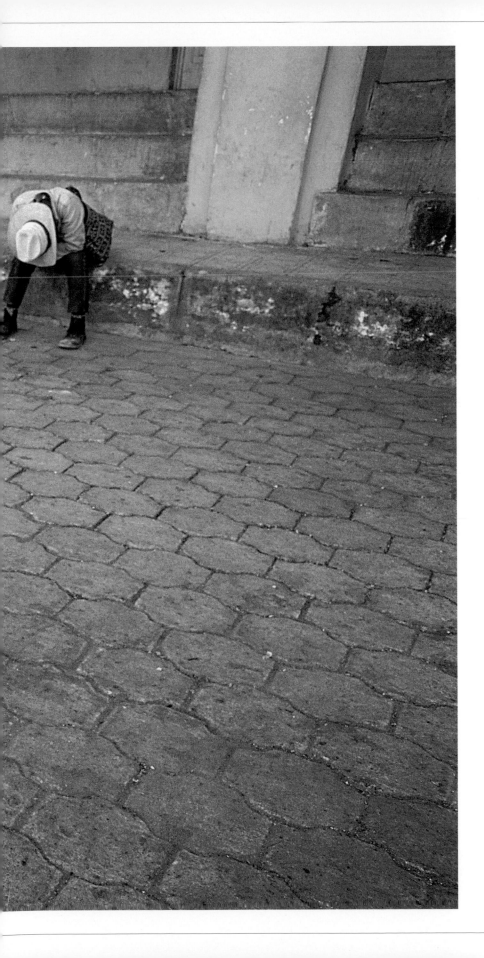

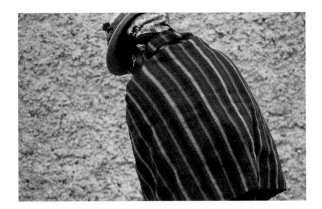

Todos Santos, Guatemala

Joyabaj, Guatemala

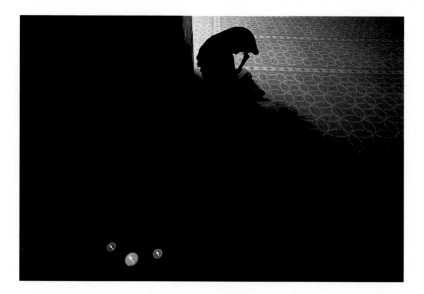

Tlacolula, Mexico

Seville, Spain

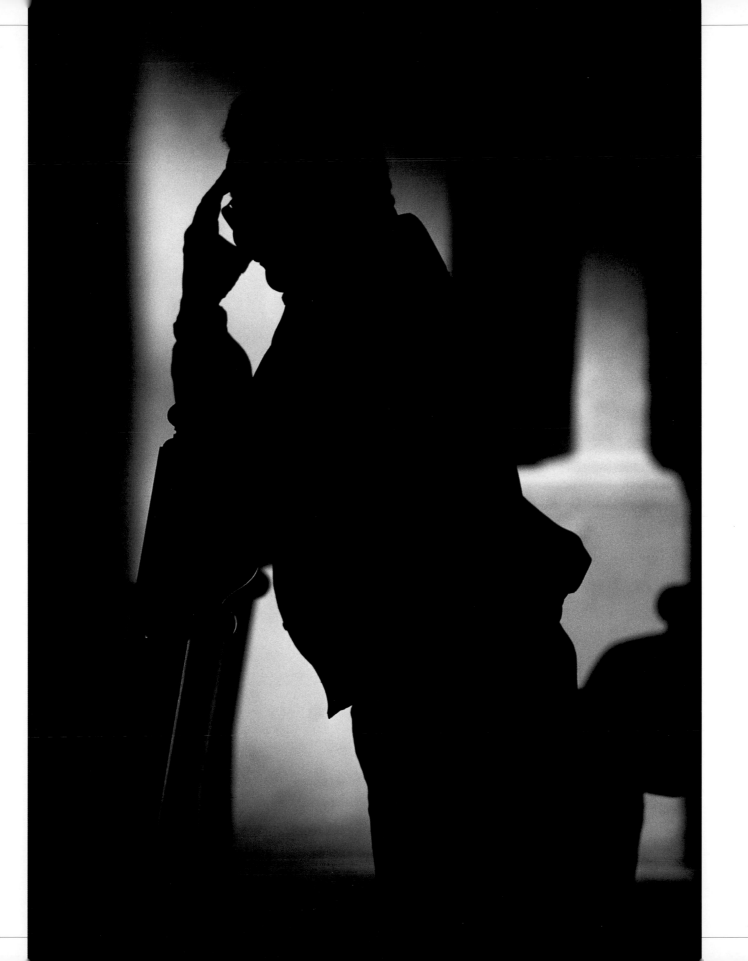

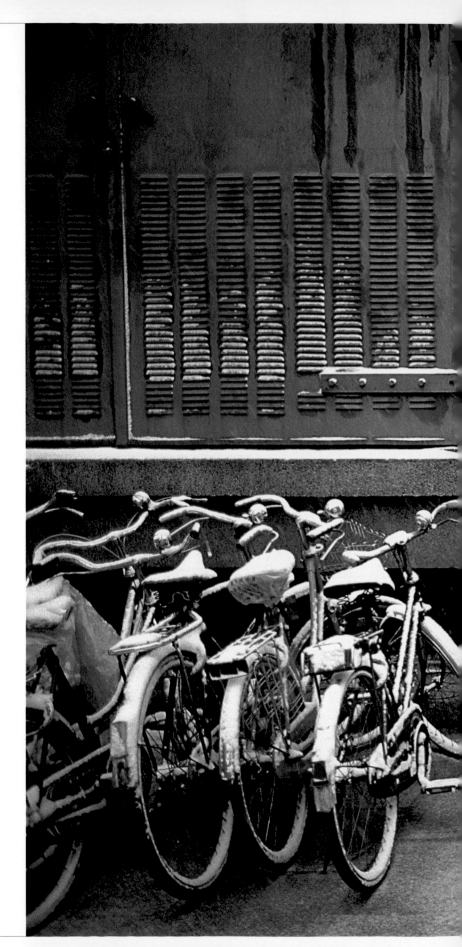

Shanghai, China

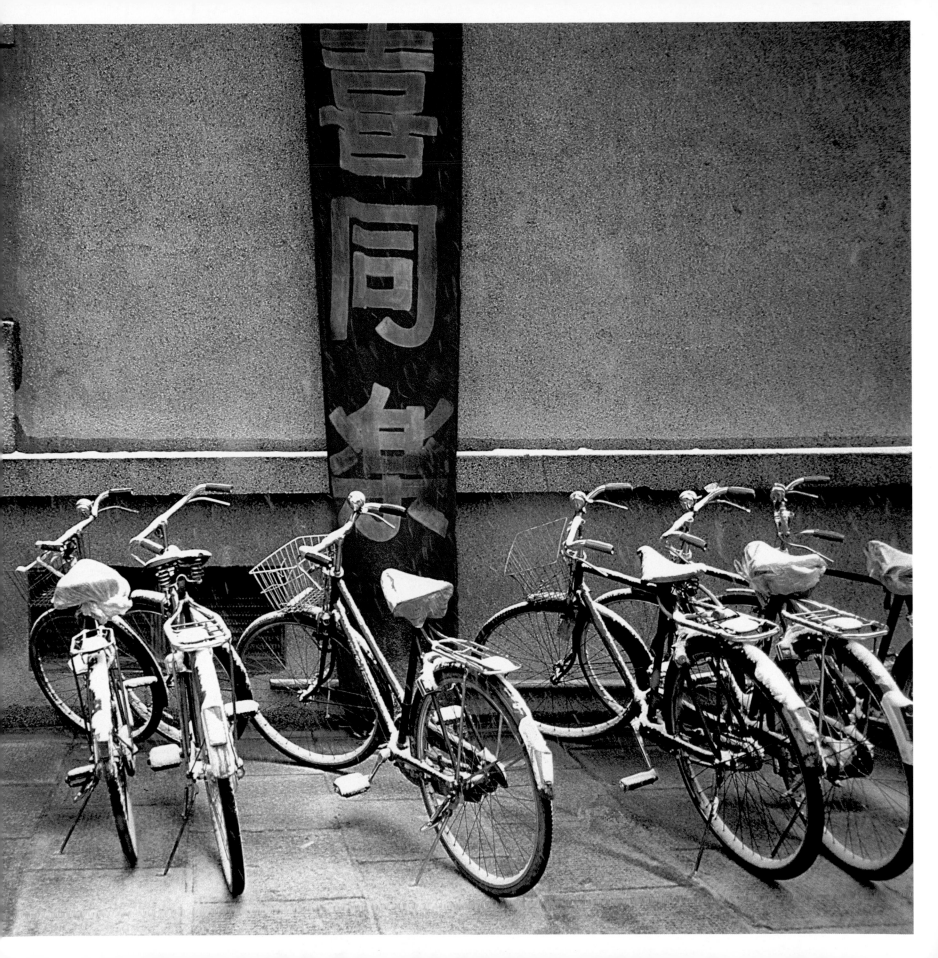

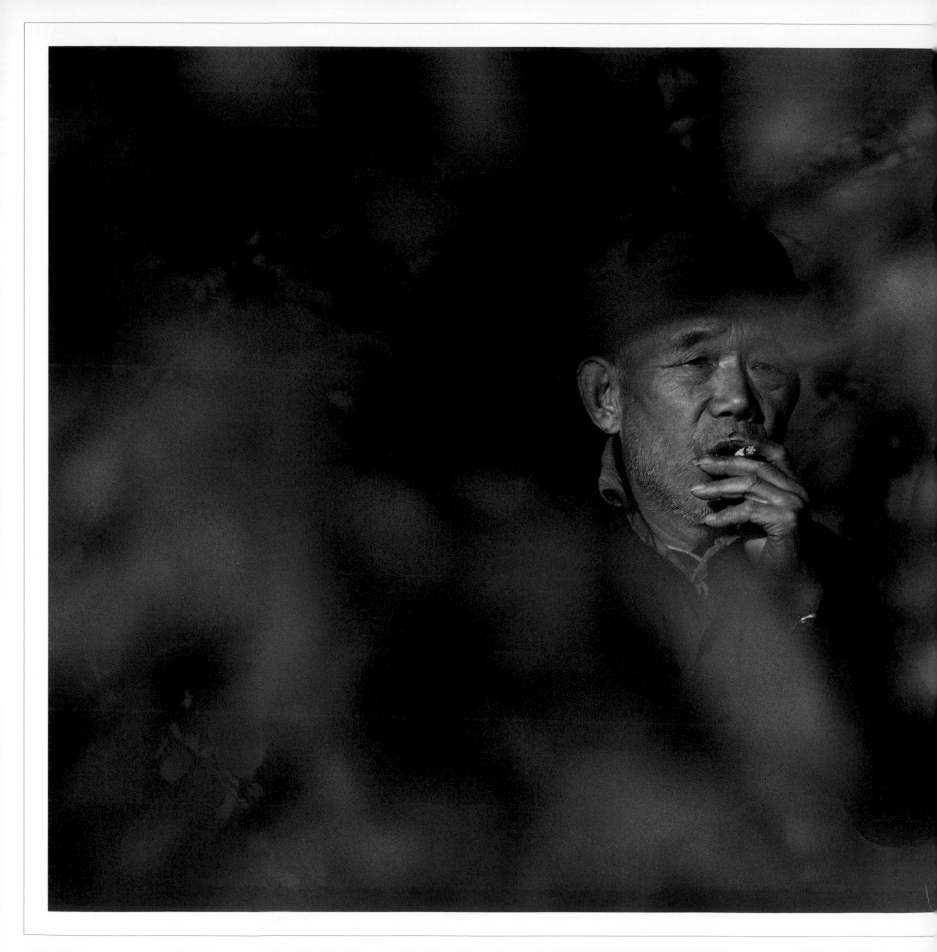

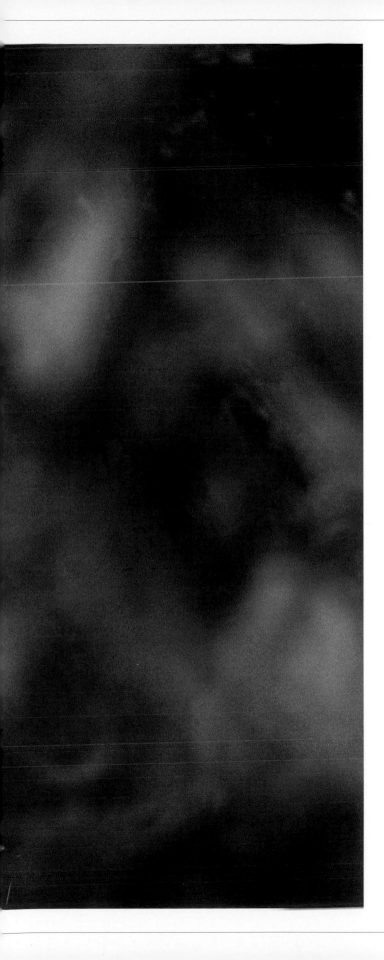

*If a man takes no thought about what is distant,
he will find sorrow near at hand.*

Confucius

Beijing, China

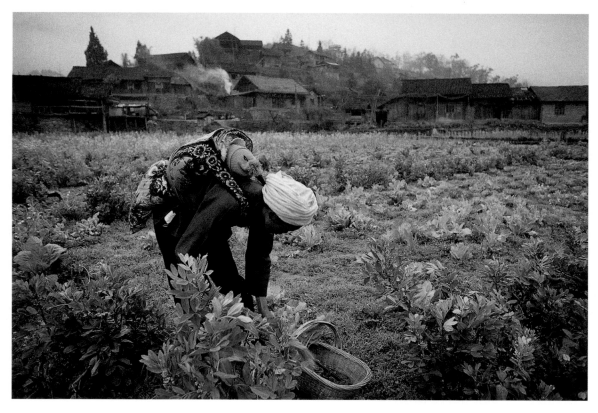

Zhijang, China

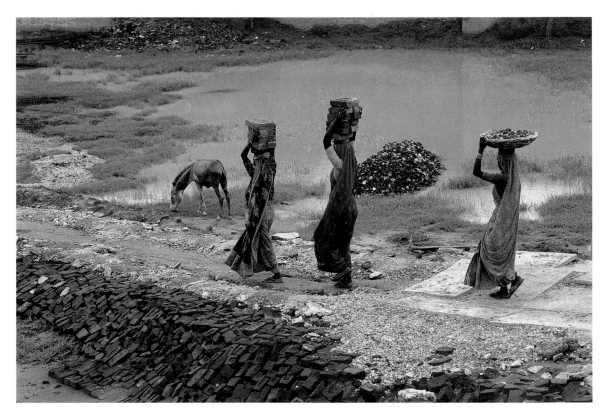

Agra, India

Leh, Ladakh, India

Menghun, China

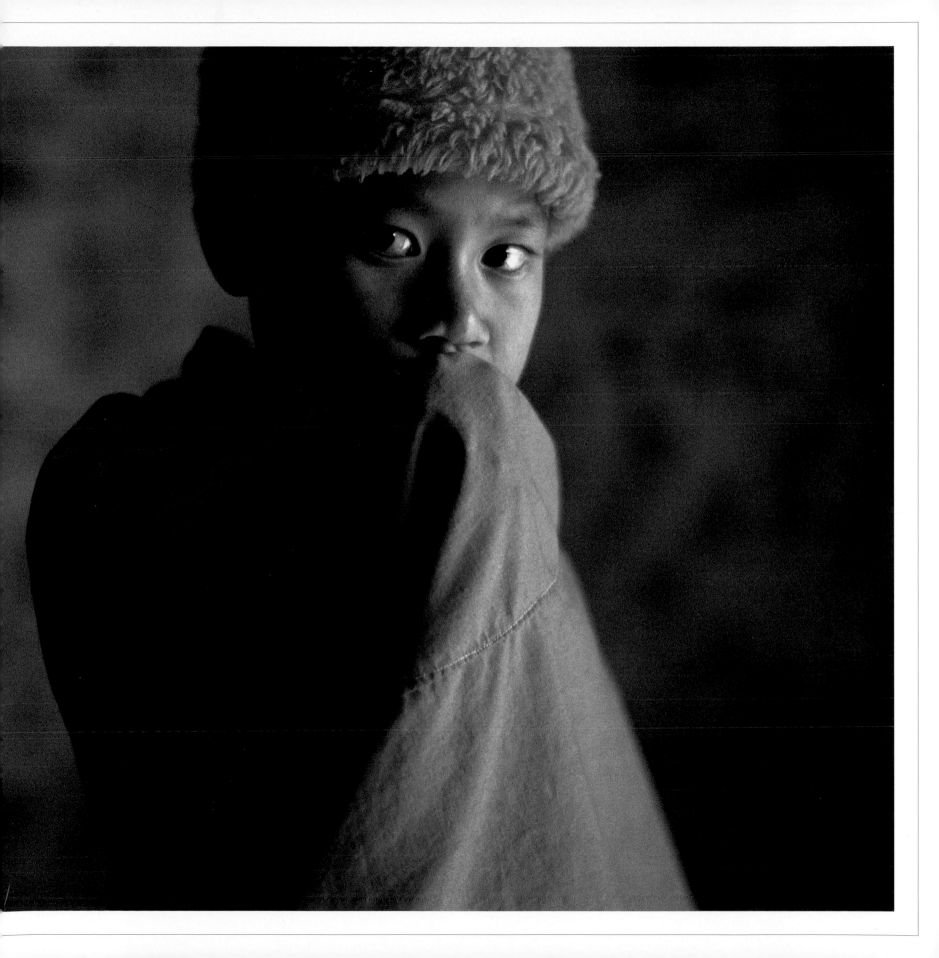

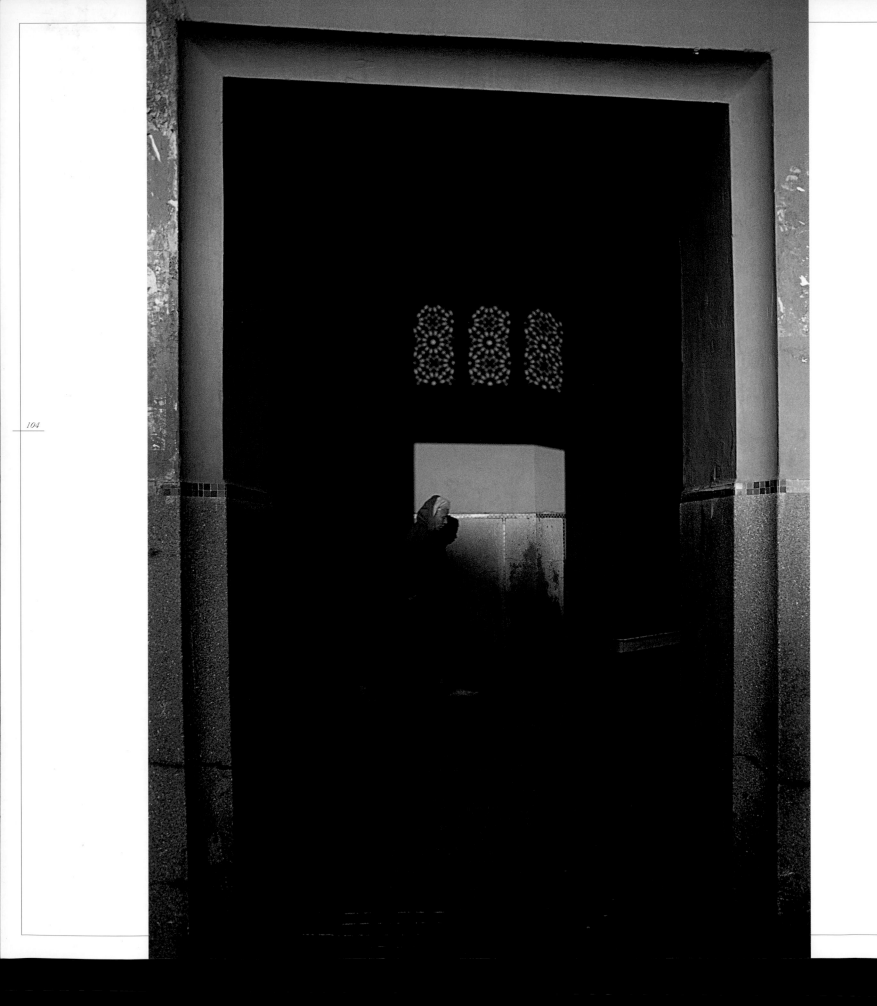

The good traveler doesn't know where he's going.
The great traveler doesn't know where he's been.

Chuang Tzu

Marrakech, Morocco

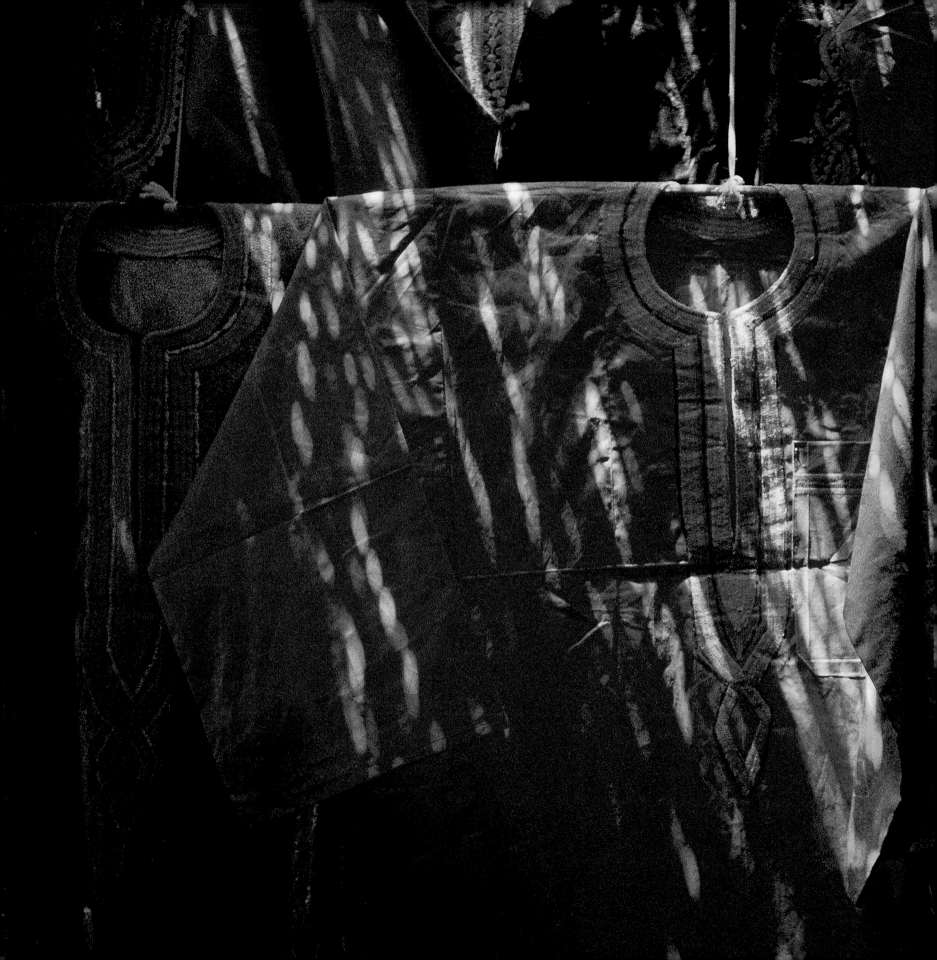

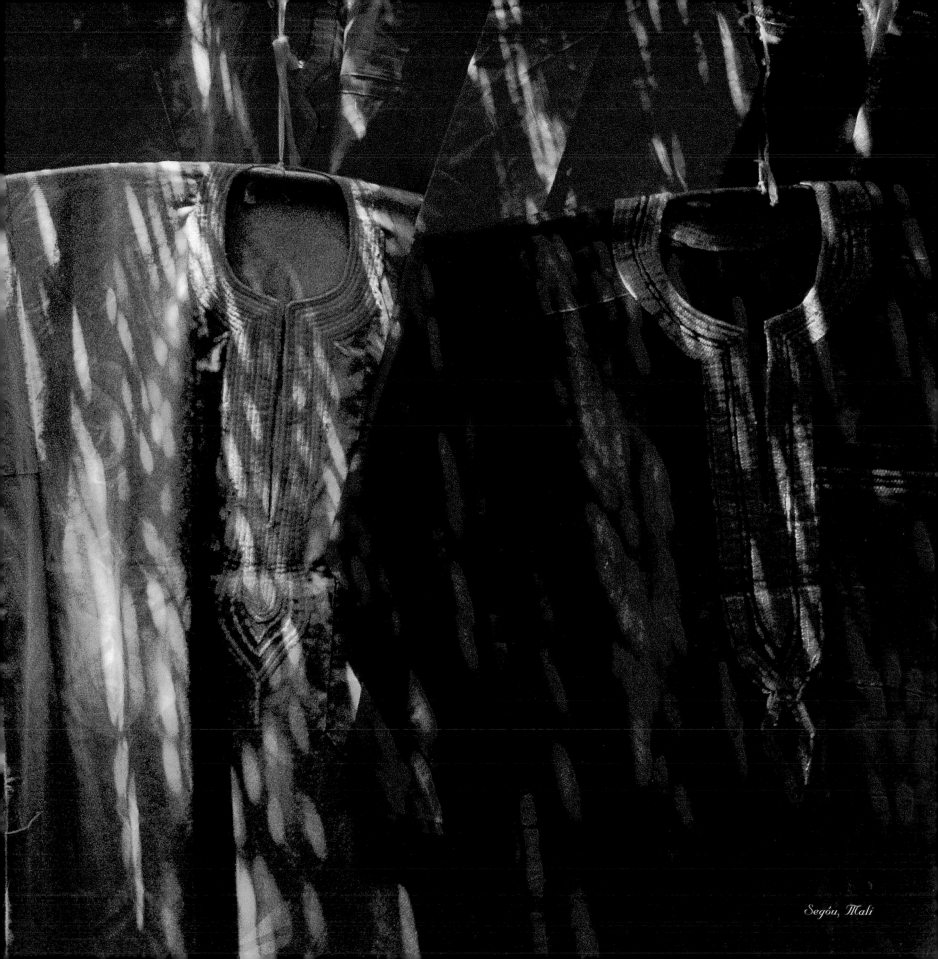

Segóu, Mali

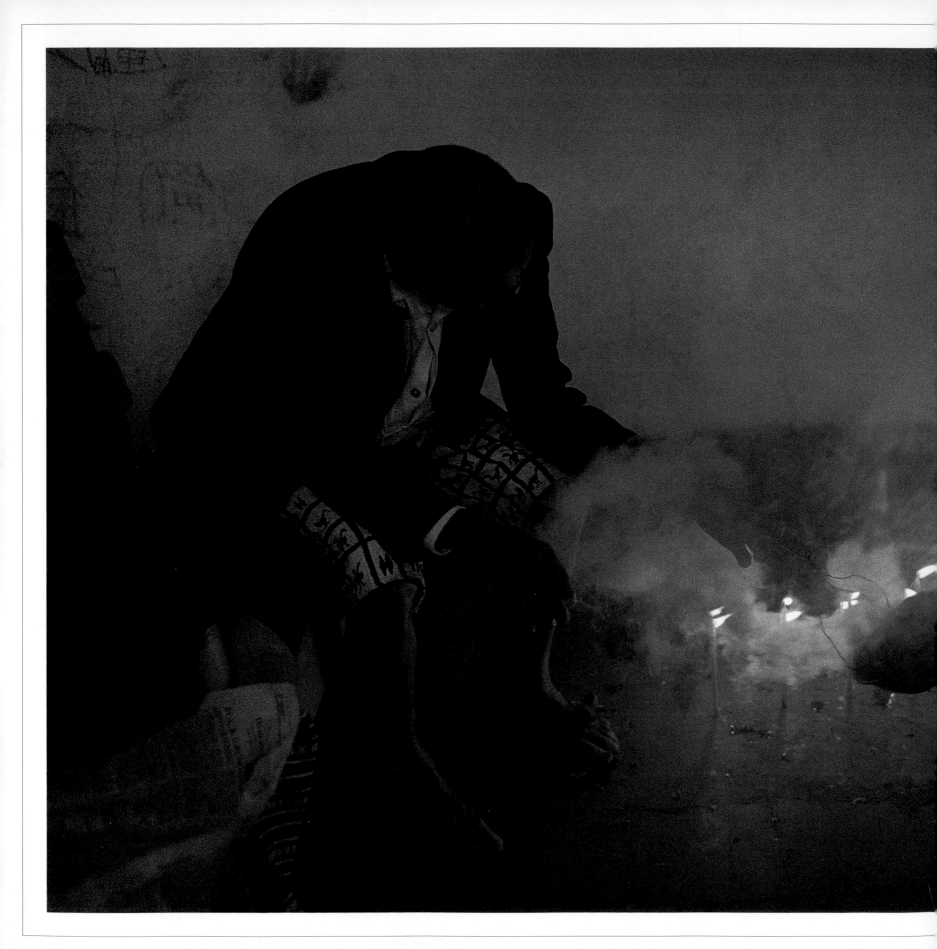

Santiago Atitlán, Guatemala

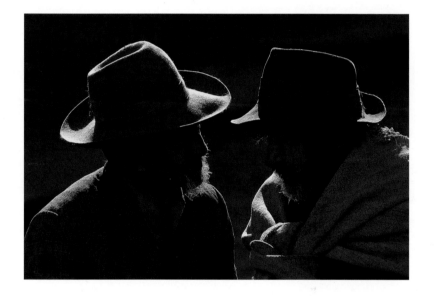

Cuzco, Peru

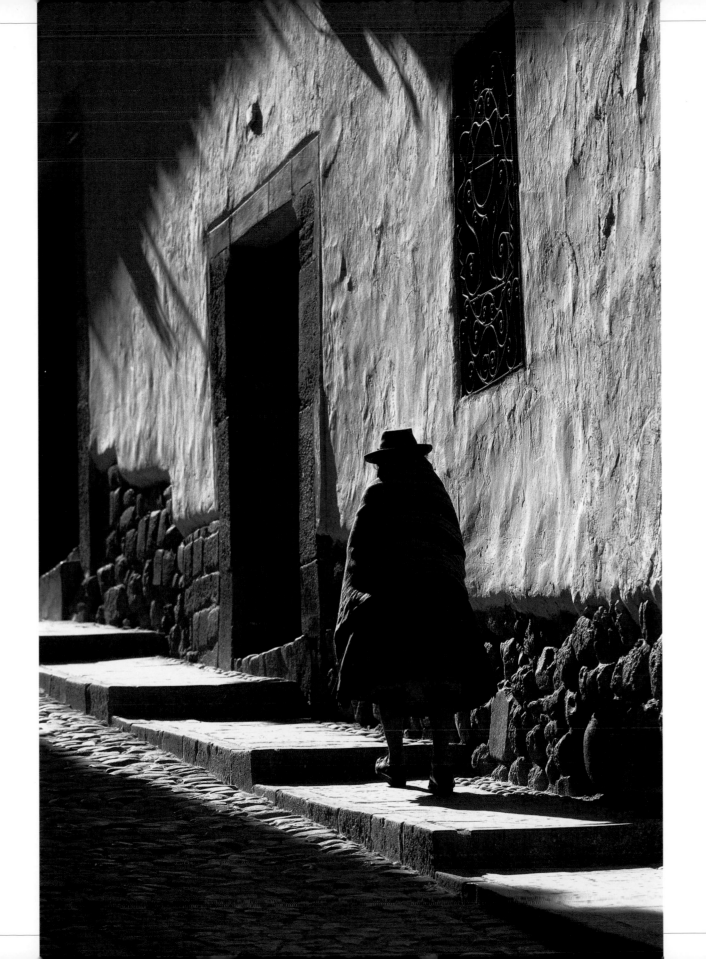

I believe the greatest morality is to acknowledge the freedom of others- to be oneself and not to be in judgement of others who are different from you.

John Cassevetes

Muthura, India

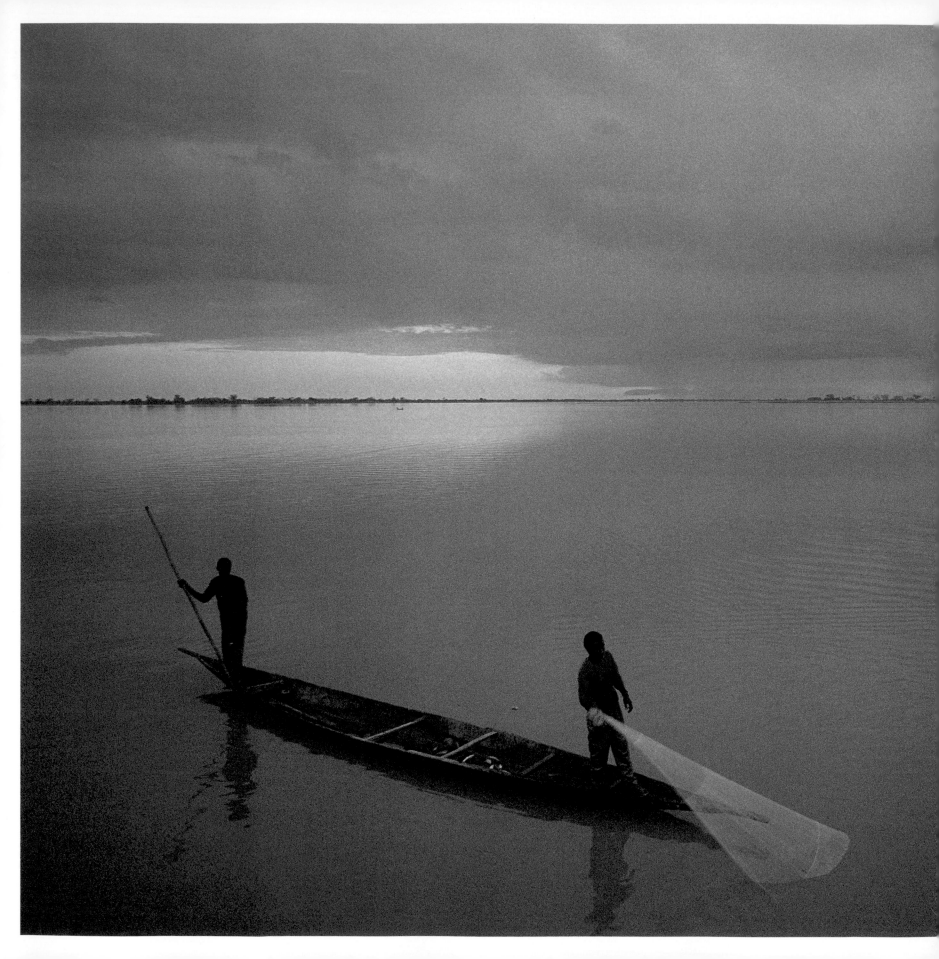

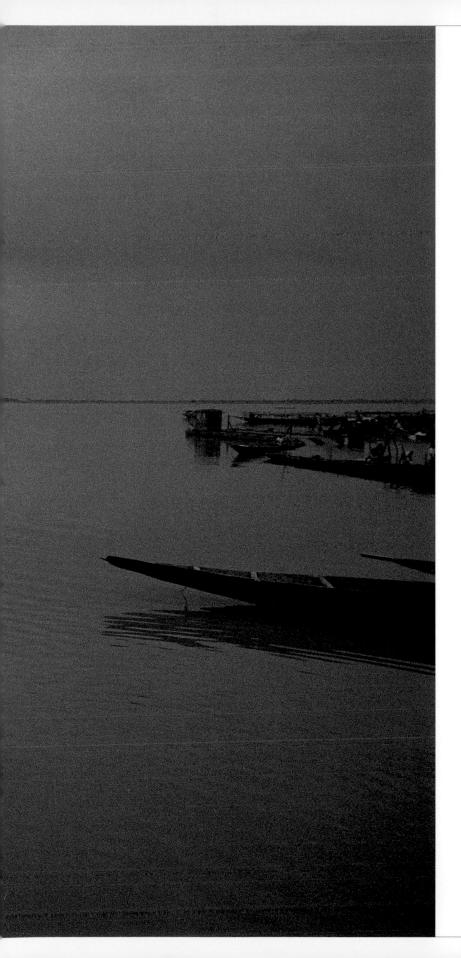

Niger River, Ségou, Mali

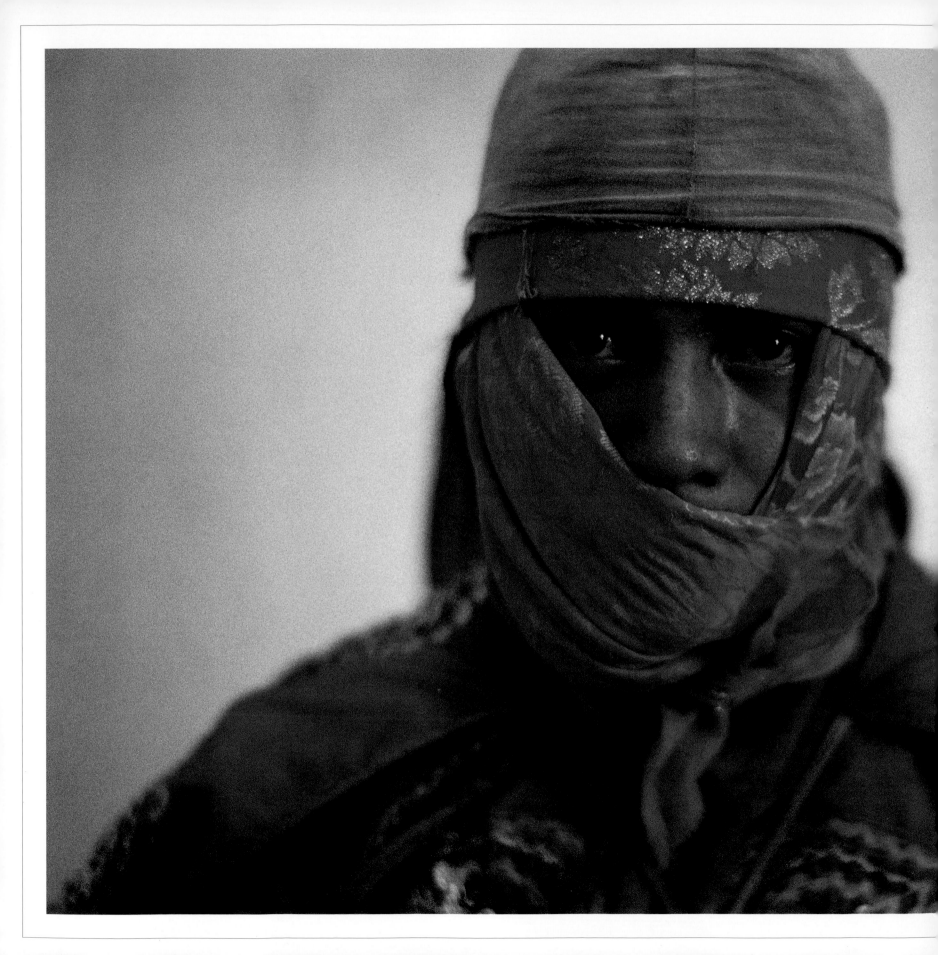

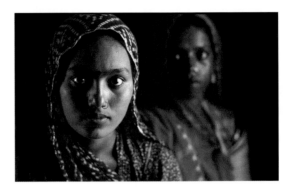

Jaisalmer, India

Joyabaj, Guatemala

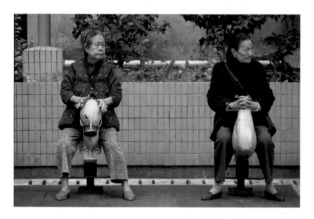

Hong Kong, China

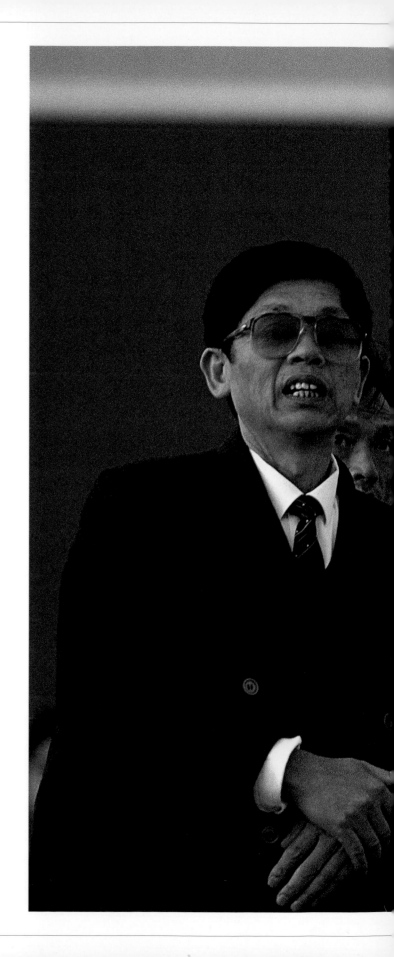

Bejing, China

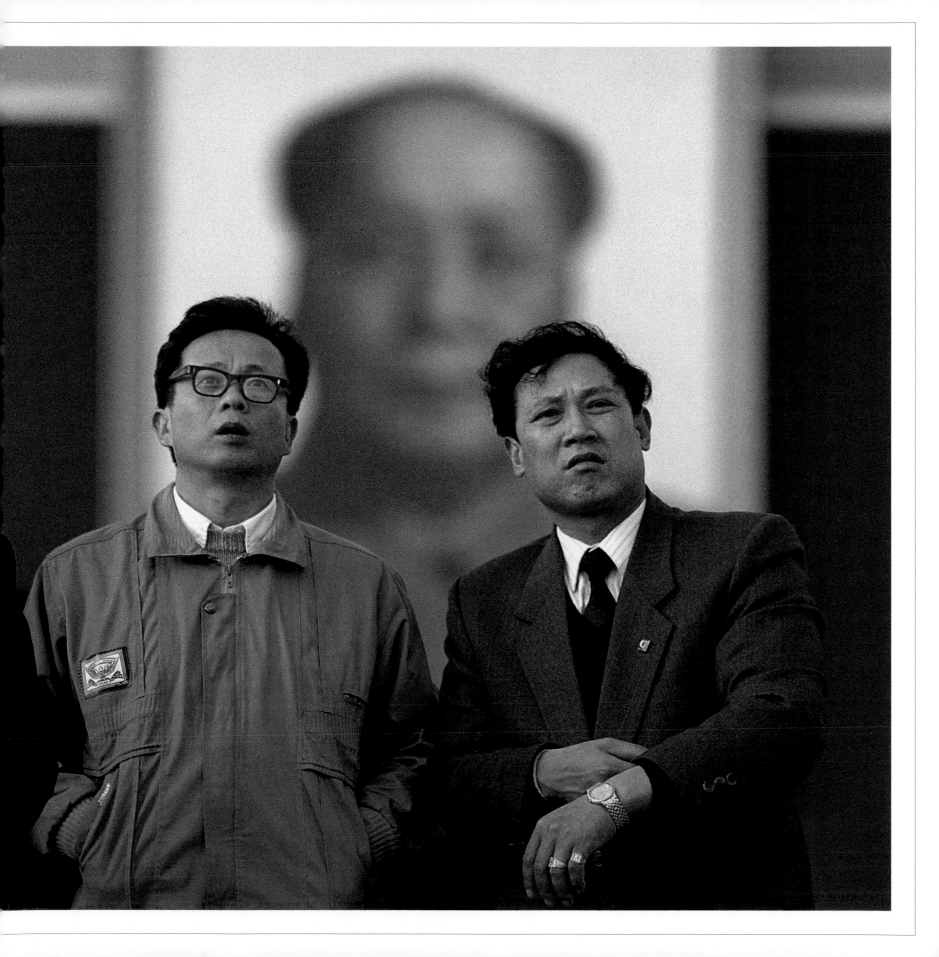

To understand is hard. Once one understands, action is easy.

Sun Yat-sen

Udaipur, India

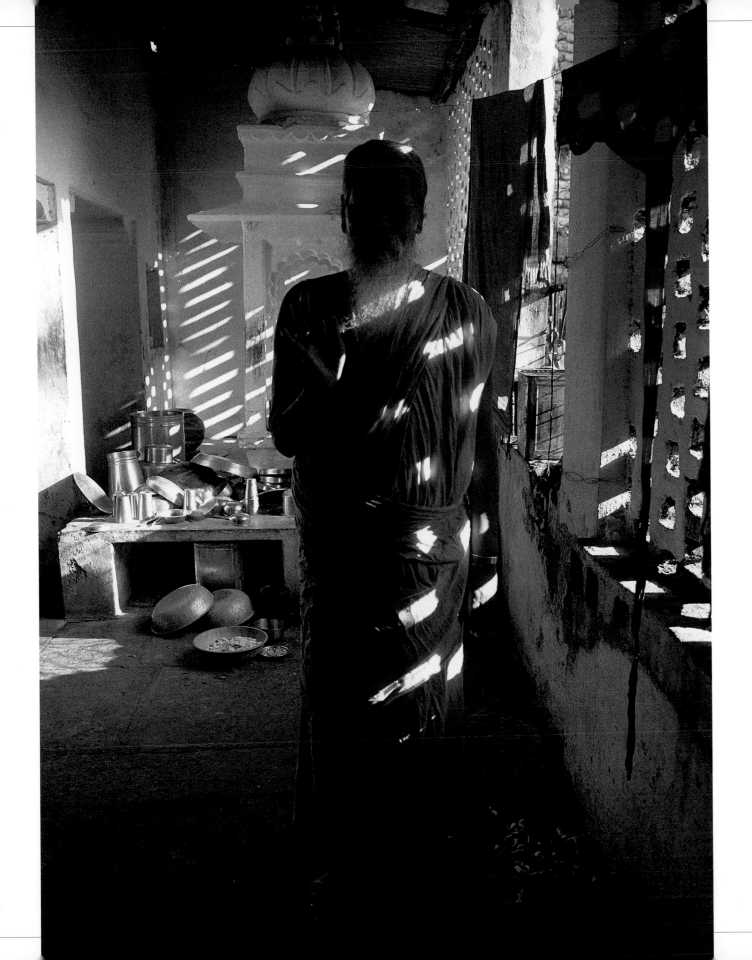

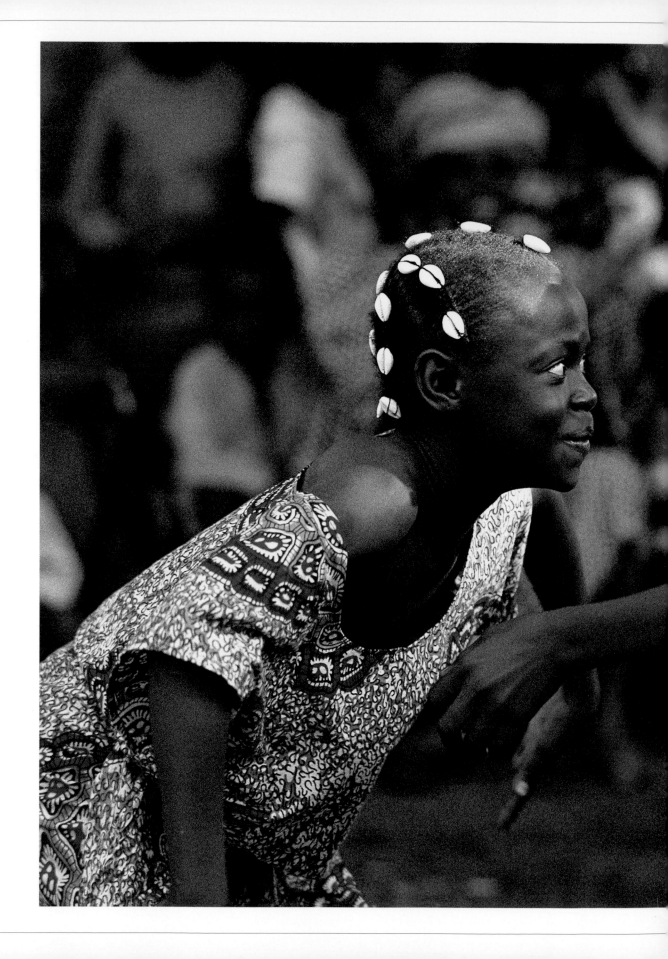

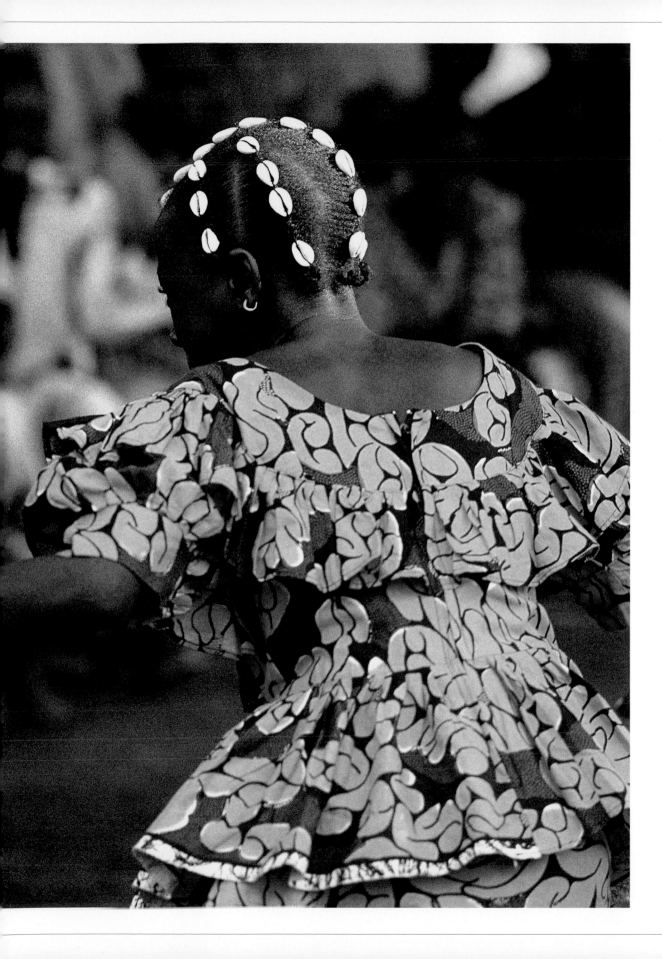

Bamako, Mali

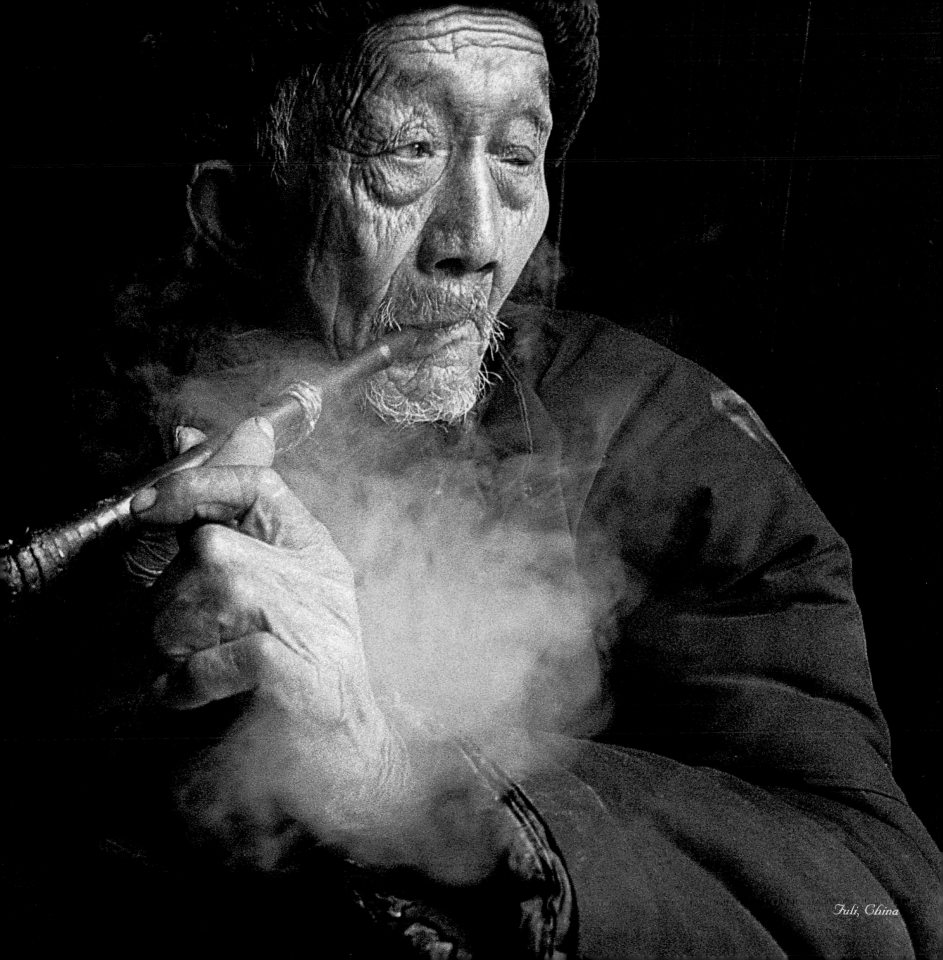

Fuli, China

And God hath spread the earth as a carpet for you,
that ye may walk therein through spacious paths.

The Koran

Cairo, Egypt

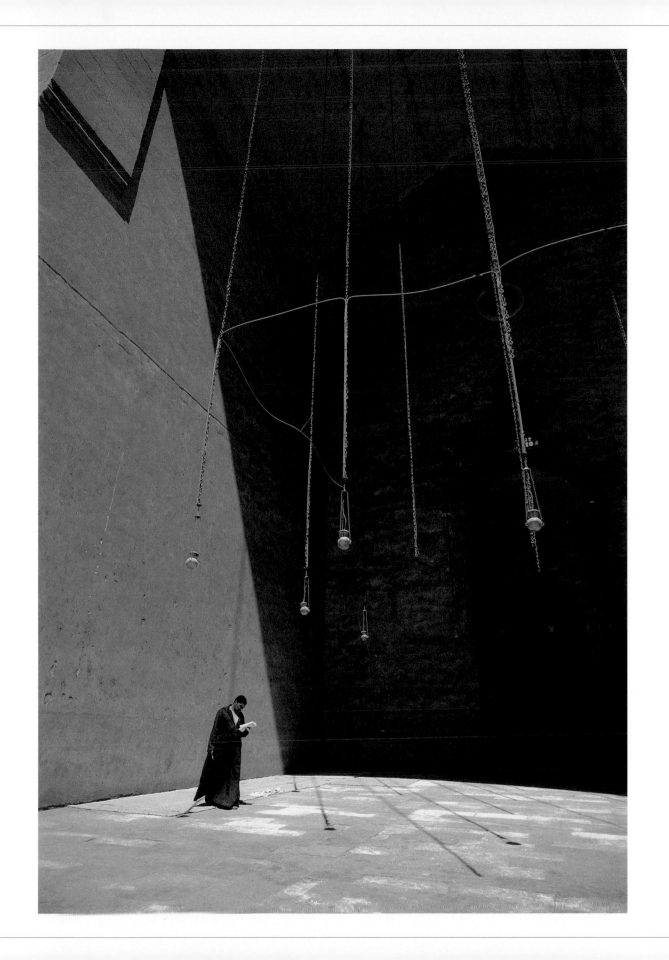

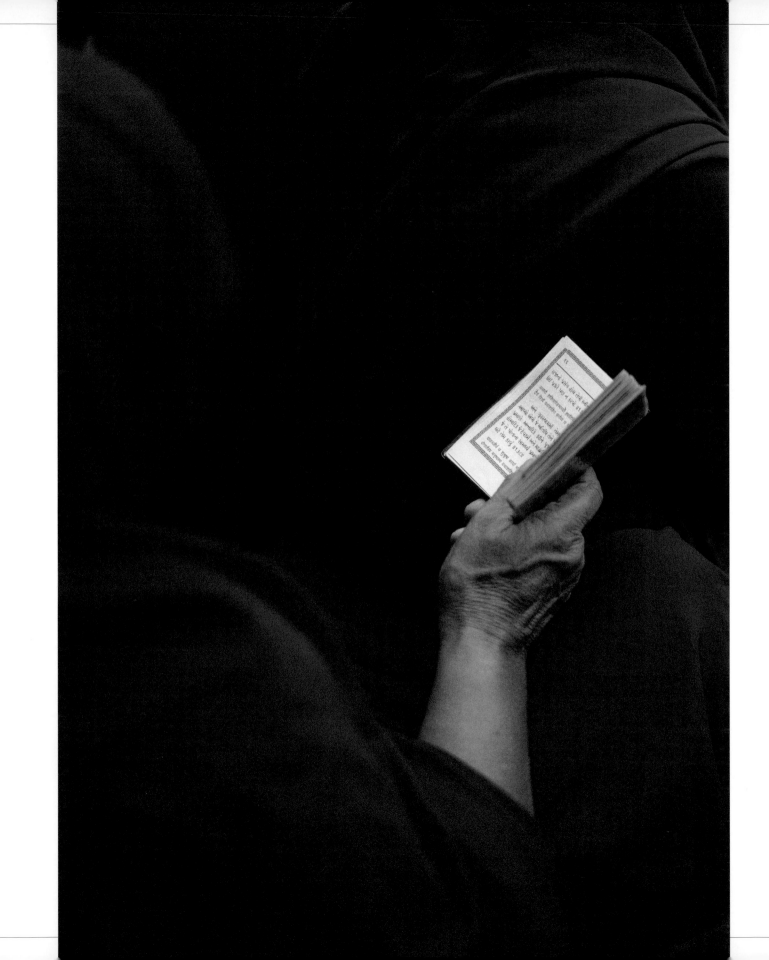

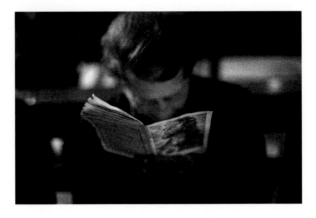

Santiago Atitlán, Guatemala

Todos Santos, Guatemala

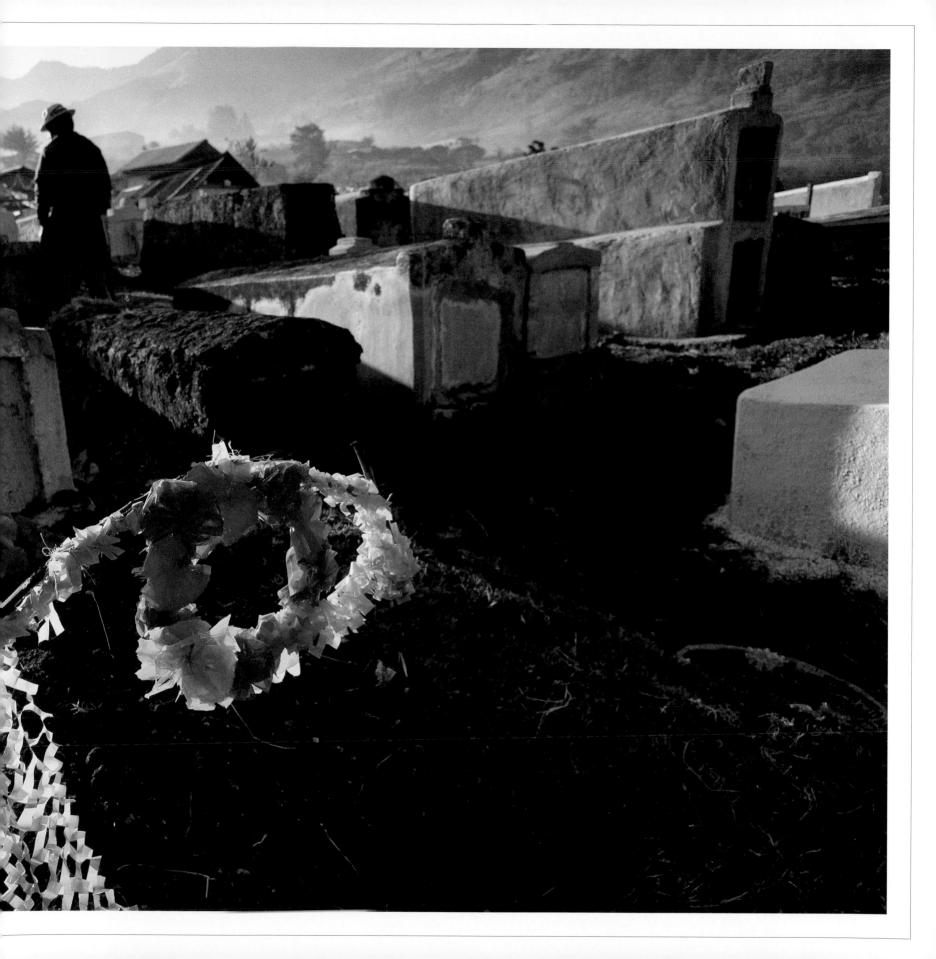

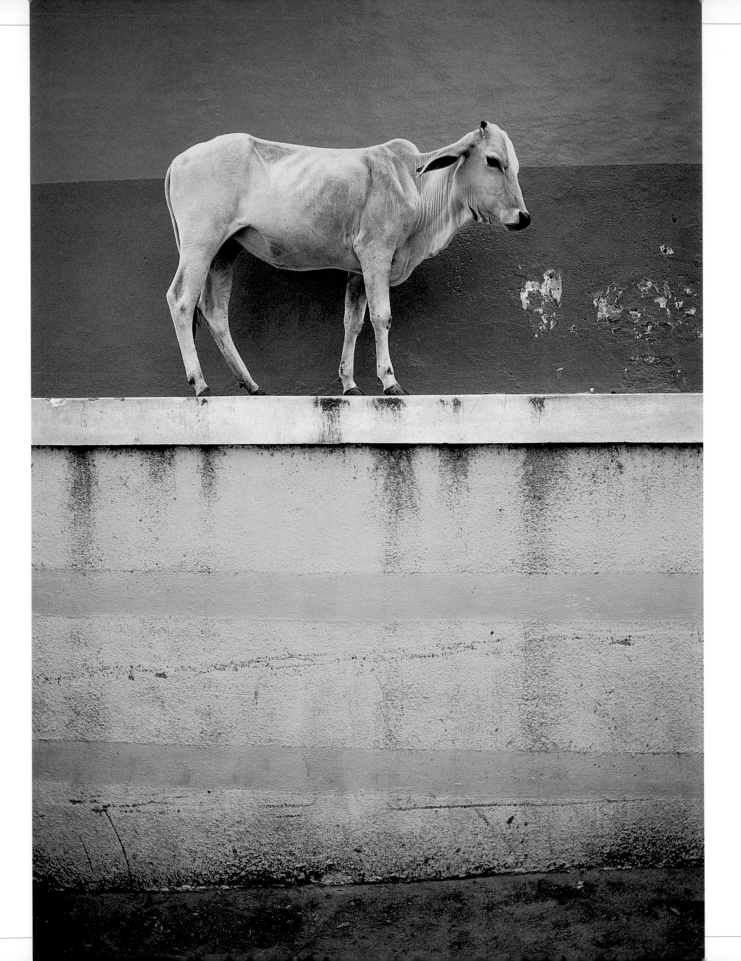

Mathura, India

Live all you can; it's a mistake not to.

Henry James

Ségou, Mali

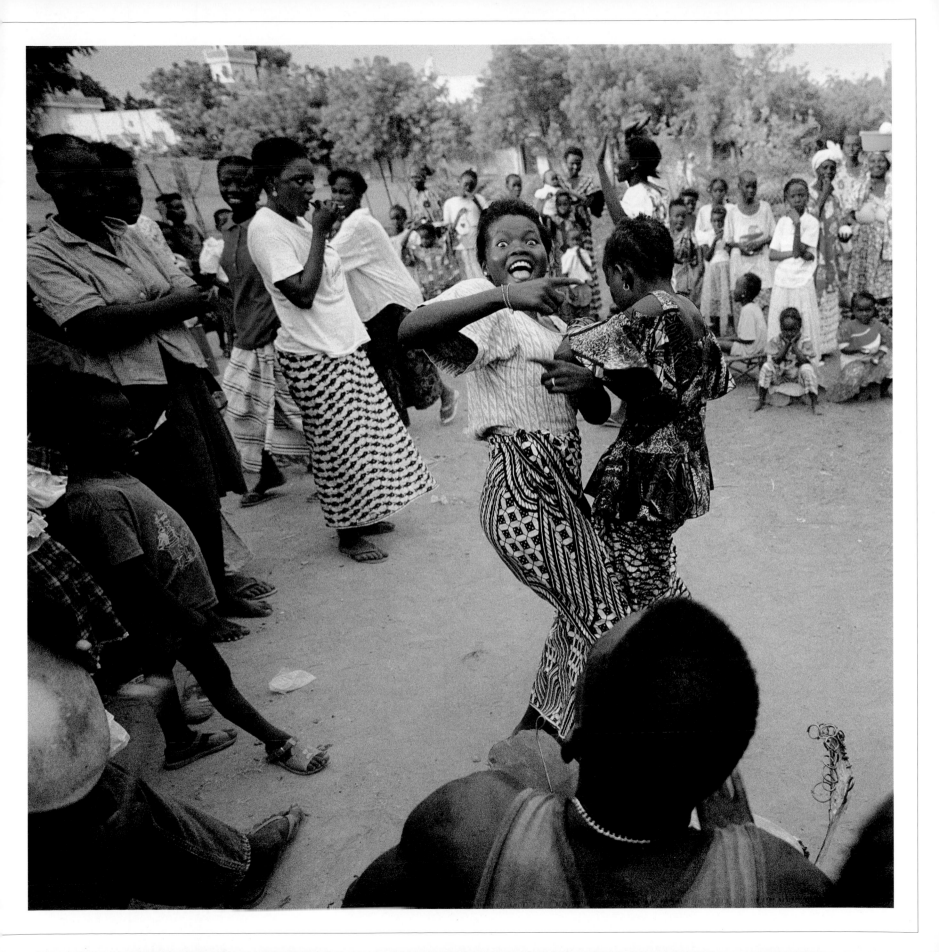

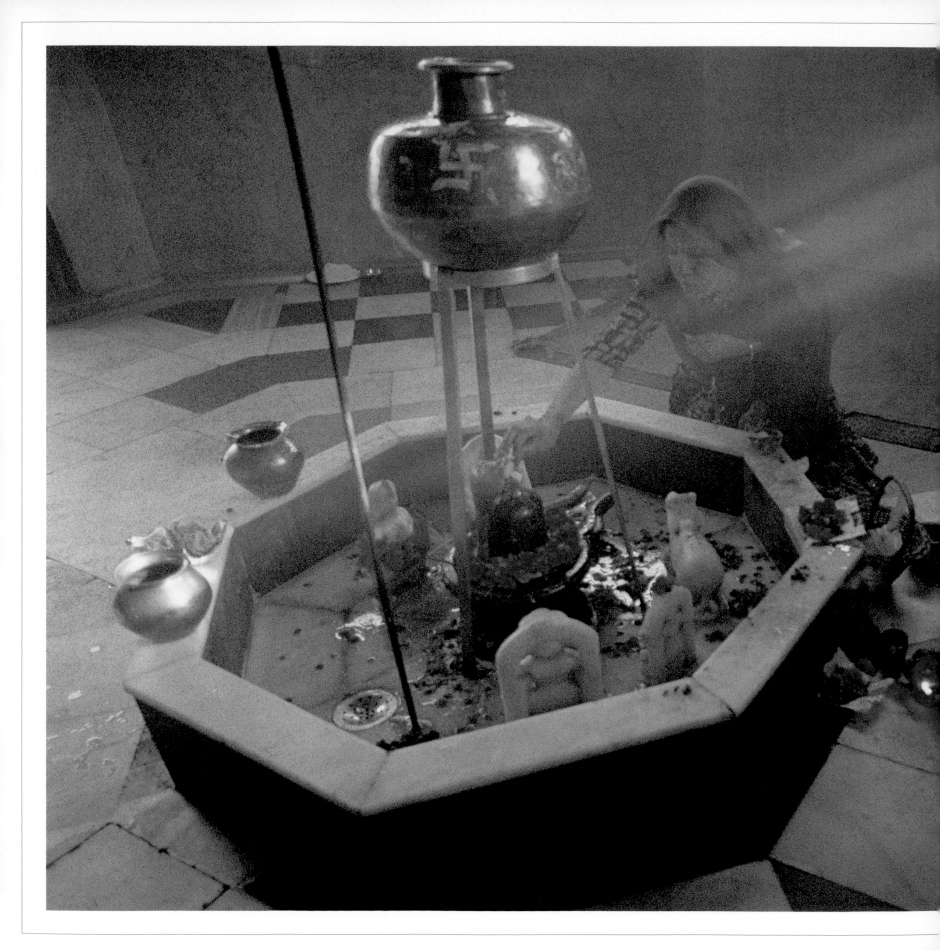

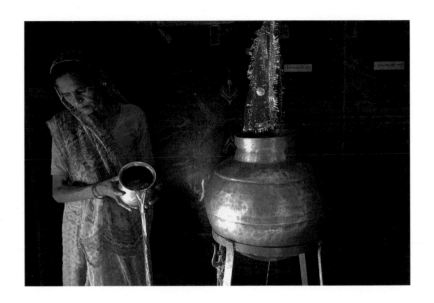

New Delhi, India

Pacific Sky

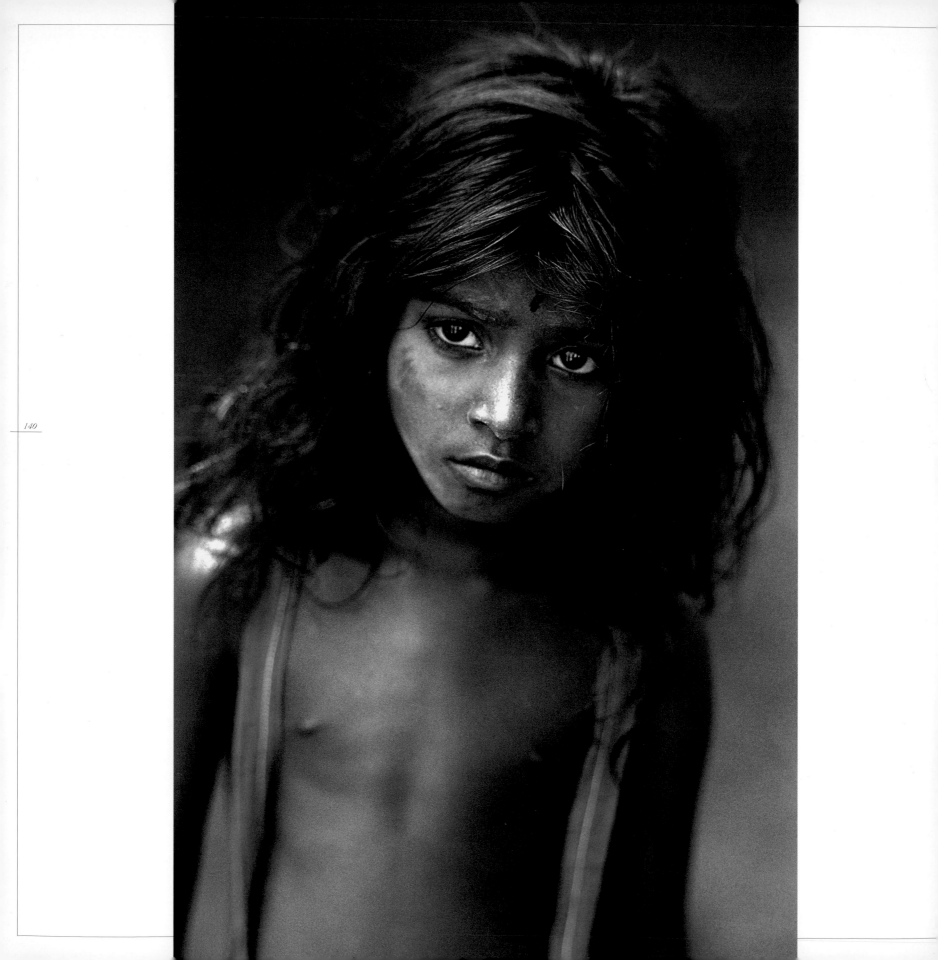

Madras, India

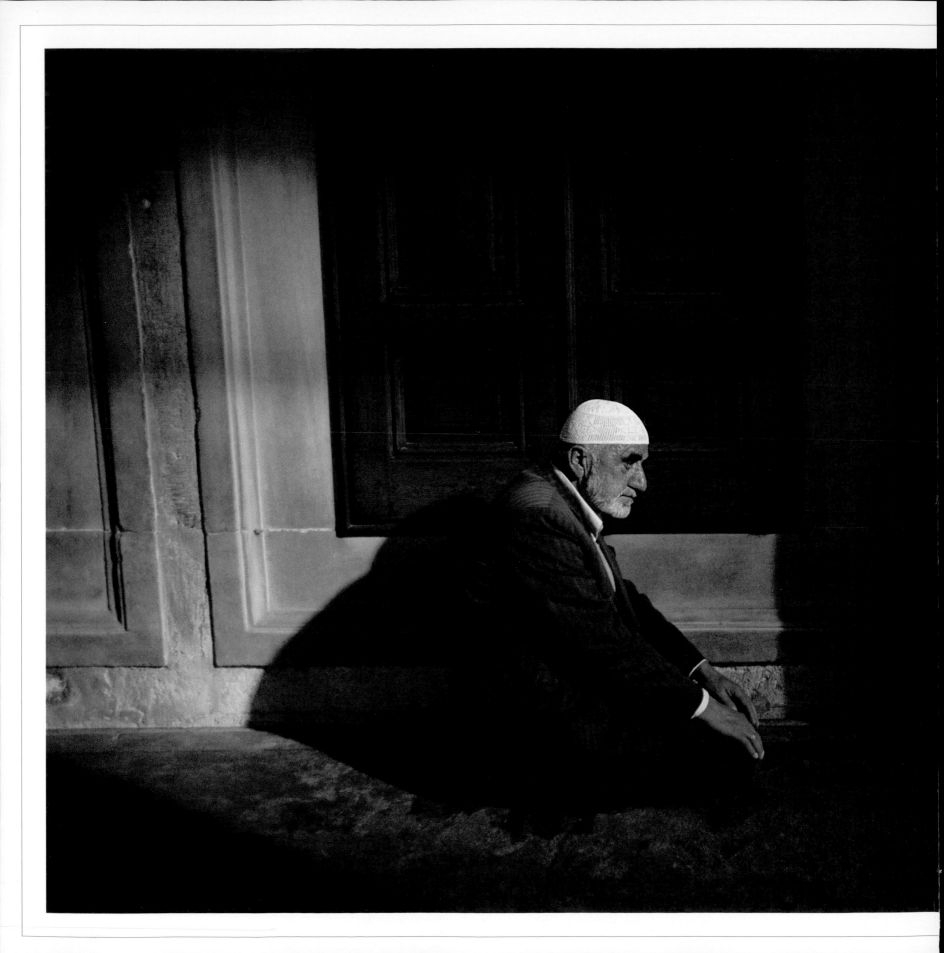

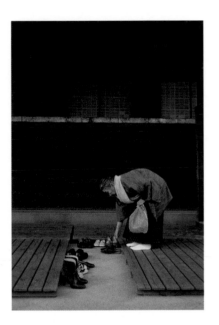

Kyoto, Japan

Istanbul, Turkey

Half the world does not know how the other half lives.

Rabelais

Niger River, Ségou, Mali

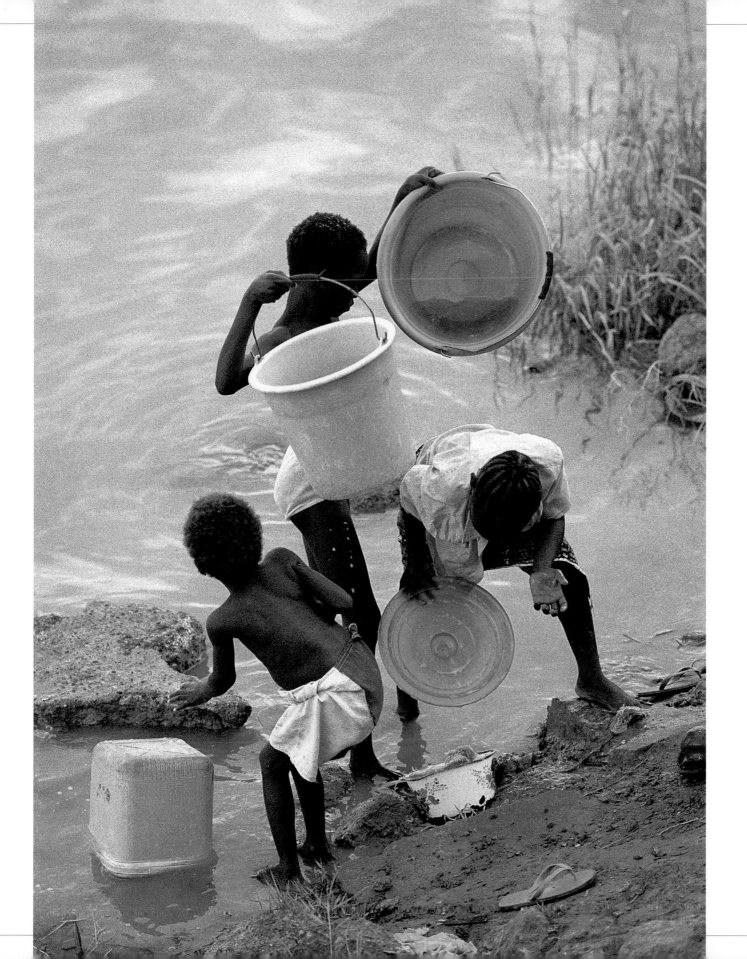

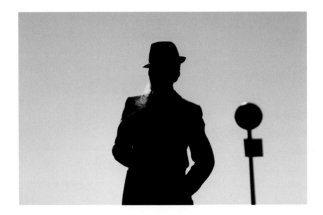

Venice, Italy

Quetzaltenango, Guatemala

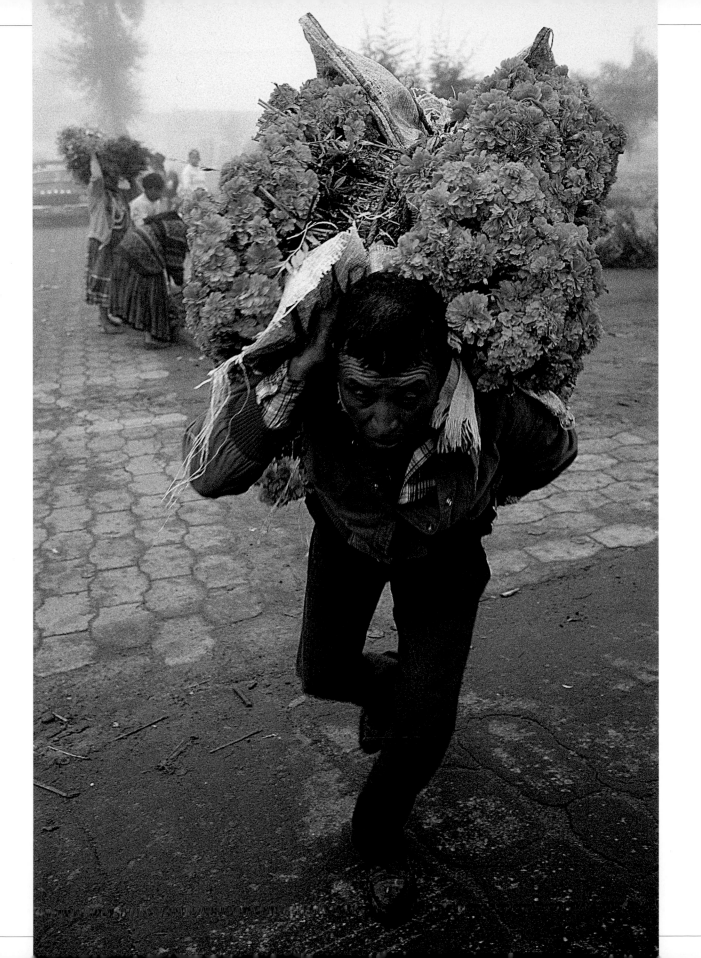

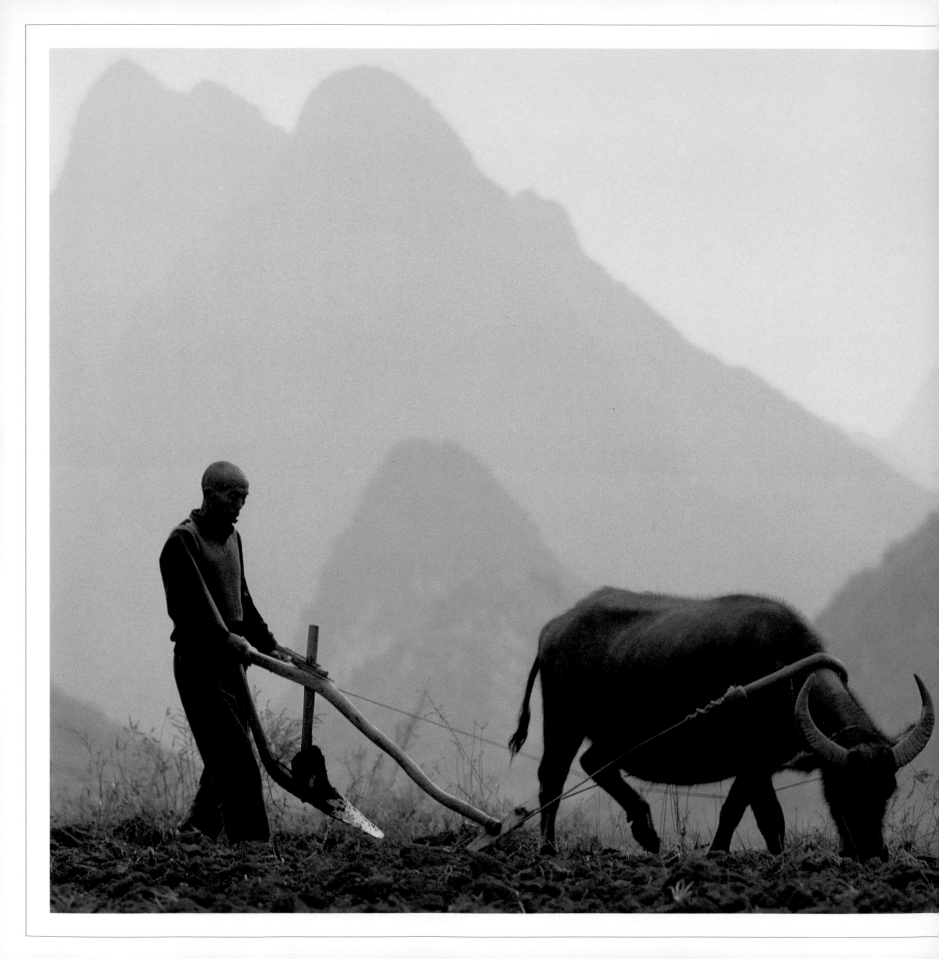

*The world begins to exist
when the individual discovers it.*

Carl Jung

Yangshuo, China

Santiago Atitlán, Guatemala

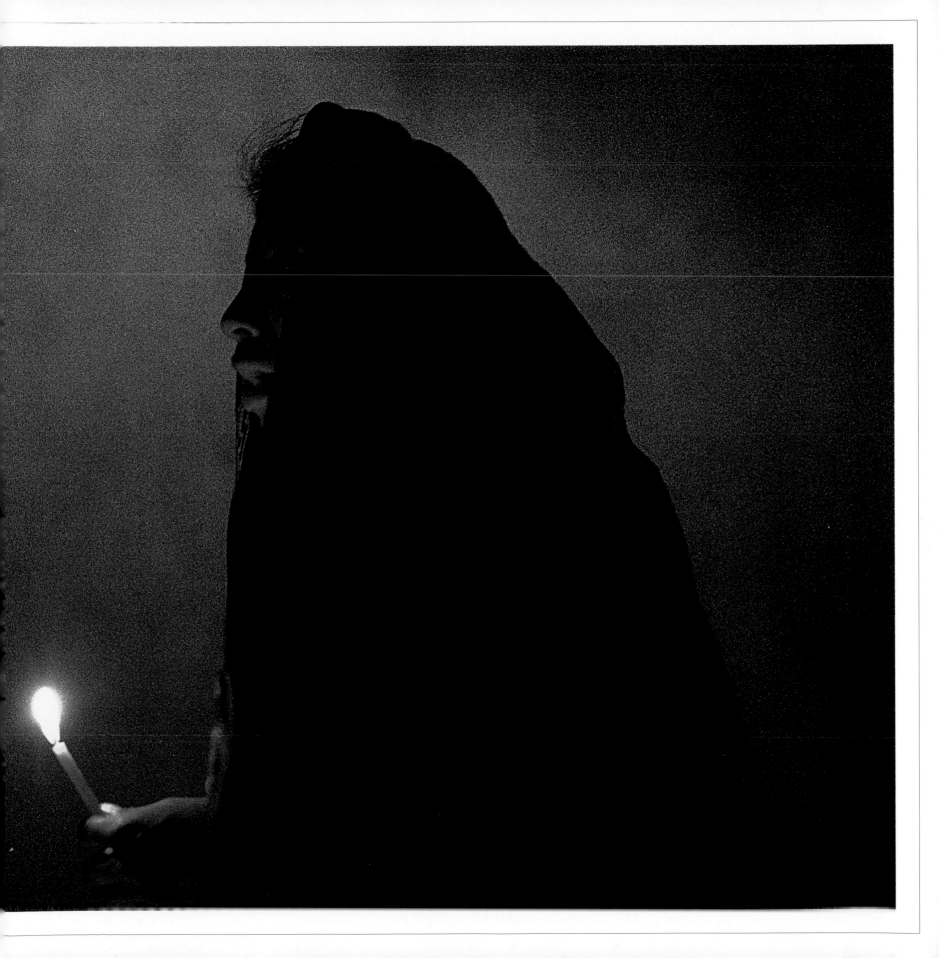

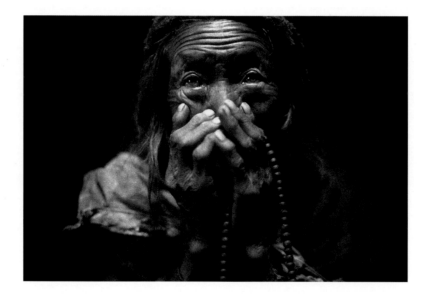

Leh, Ladakh, India

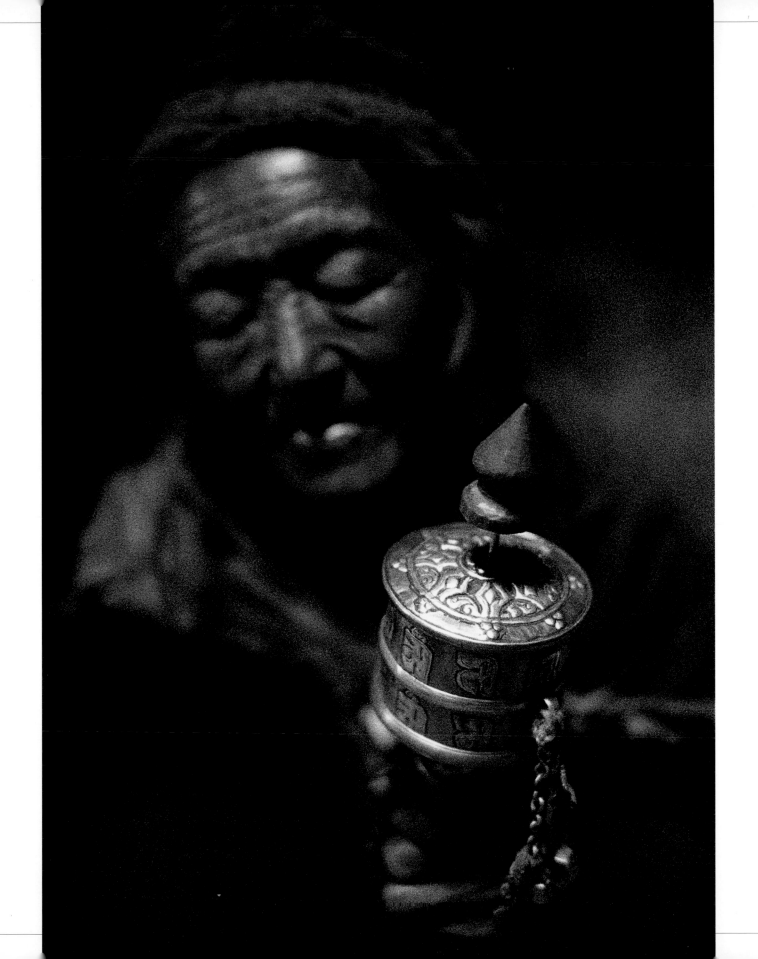

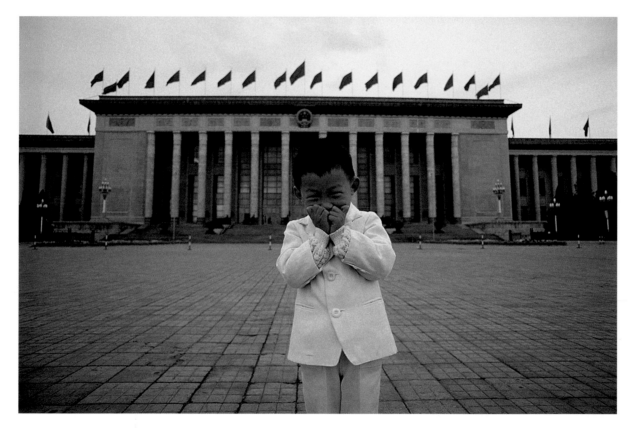

Bejing, China

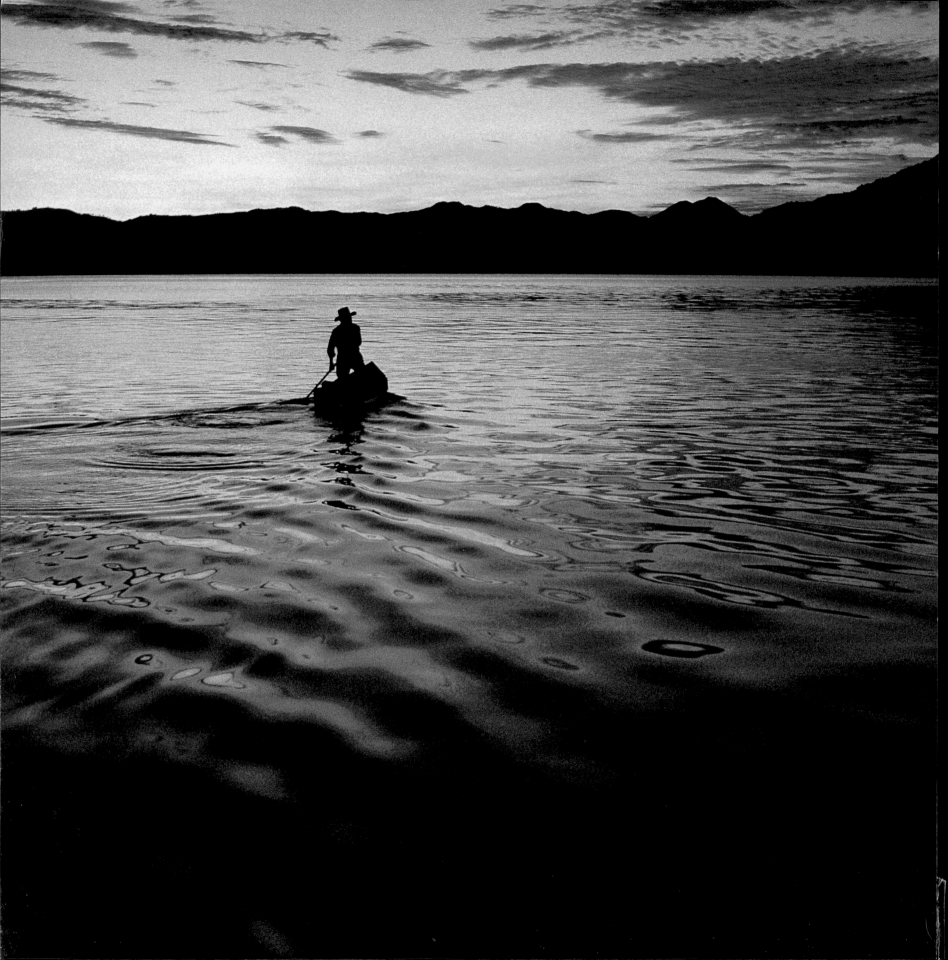

The great thing in this world is not so much where we stand,
as in what direction we are moving.
We must sail sometimes with the wind and sometimes against it,
but we must not just drift or lie at anchor.

Oliver Wendell Holmes

Acknowledgements and Notes

David Bridge's beginning text refers to the work of the gifted LIFE photographer Eugene Smith. Smith's photographic philosophy was clear: "My station in life is to capture the action of life, the life of the world, its humor, its tragedies—in other words, life as it is, a true picture, unposed and real." But that was decades ago. Now the language of photography has been extended—the emphasis of meaning has shifted—shifted from what the world looks like to what photographers feel about the world and what they want the world to mean. By seeing things *they* can be seen and by feeling things and capturing those feelings on film *they* can be felt. So now photographers are doing much more than simply liberating moments. To paraphrase photographer Jerry Uelsmann—they are inventing a language at the same time they are using it. Instead of a mere reproduction, photography has become a transformation.

Today to accomplish their goals, photographers require equipment that is not only reliable, but fast and simple to operate—equipment that provides the shortest circuit between the brain and the fingertips. This photographer has been lucky. My sincerest thanks to Bill Heuer and Blake Ziegler of CONTAX, Inc., for providing the ST and S2 bodies and Carl Zeiss lenses that made photographic life a pleasure in all four corners of the globe.

In 1935 the Eastman Kodak Company introduced to the world the first commercially and critically successful color photographic film—Kodachrome. Invented by two enterprising employees, Leopold Mannes and Leopold Godowsky, it became a much revered film that received wide acclaim—even in song. Back in 1973 Paul Simon in his hit song *Kodachrome* proclaimed the virtues of a film that "makes you think all the world's a sunny day." But perhaps the most significant testimony to the film's reproductive qualities is that it is still very much in use today. Witness the images on the preceding pages. Thank you to those unsung heroes—the countless Kodak engineers and scientists who have refined Kodachrome over the years. And special thanks to Kodak personnel Steve Behen, Galen Metz, Jeff Notte, Sally Robson and William Wong for getting all those red and yellow boxes into my camera bag.

But photographers require more than cameras and film. They also require light. They cannot do business without it. For many photographers it is the heart and soul of their images. Hunting light—searching for light becomes a primary mission. We often hear statements like "the

light in Florence is magnificent" or "the light in the desert is extraordinary." The fact is there is good light everywhere. And every time there's a change in the light there's a whole new world to see. It is a photographer's task to *see* light, then seize it and concentrate it in the small rectangular frame of his or her viewfinder. When one can see light clearly, as master photographer Ernst Haas did in his prime, it becomes poetry, philosophy and religion all in one.

In a speech to the House of Commons in 1873 Benjamin Disraeli said "a university should be a place of light, of liberty, and of learning." So in a very real sense educators need and use light, too. Unlike photographers who work to secure it on a small piece of film, educators seek to spread it as far and wide as possible. Before any of mankind's problems can be solved light first must be shed on them. No group of educators understands this more or spreads light more effectively and further than the men and women who comprise the Institute for Shipboard Education. The thousands of students who have taken a semester off their land based campuses and done it instead at sea will testify to this. They know that travel—especially travel by sea—teaches toleration and breeds under-

standing. They know they don't live in a world all alone—their brothers and sisters are here too. They know they have participated in a true apprenticeship for life. In effect, they have seen the light.

To the Institute's Members: Christine Asenjo, Julian Asenjo, Jennifer Babin, Jane Bonheim, Max Brandt, Becky Drury, Kathleen Forsythe, Michele Giometti, Marty Greenham, Marcia Gruver, Monique Howze, Ellen Kolovos, Ozelle Krukowski, Jennie Leghart, Cathy Light, Les McCabe, Salvatore Moschella, Patricia Nickels, Mary Jo O'Malley, Nicole Osikowicz, Steve Rine, Kimberly Szczypinski, John Tymitz, Paul Watson and Jill Wright—thank you for your unwavering support over the years. And thank you for the world—the best studio any photographer could ever want.

Near the end of David Bridge's text he speaks to "man's inextinguishable capacity for hope." Yes, there is light at the end of the tunnel. And maybe—just maybe a small slice of that light is *Sea Light*.

Paul Liebhardt
Oaxaca, Mexico
September 7, 1997

Colophon

Concept, creative production and general project management by Media 27, a Santa Barbara, California based creative production company.

Technology by Newforce, a systems and network integration company specializing in digital imaging and pre-press.

High resolution scans, separations and proofs by Santa Barbara Color. Final art was output to film at 175 lpi/3600 dpi. All film, proofing materials and chemicals by DuPont.

The software: Quark XPress 3.32, Adobe Photoshop 4.0.1, Adobe Illustrator 7.0, LinoColor 4.2, Xinet K-AShare 9.0, AppleShare 5.0, Agfa Taipan 1.1 RIP and Retrospect 4.0.

The hardware: Power Macintosh PCI workstations with Asanté Fast Ethernet Cards, Silicon Graphics servers with Micronet RAID 0 storage, BayStack 350T 10/100 Ethernet switches, Linotype-Hell Tango drum scanner, Agfa Avantra imagesetter with Compaq 850R Dual Pentium server, Seagate Cheetah and Barracuda hard drives, DuPont WaterProof system, IRIS 5030fx inkjet printer, Newgen DesignXpress 12 laser printer and ADIC DLT tape library.